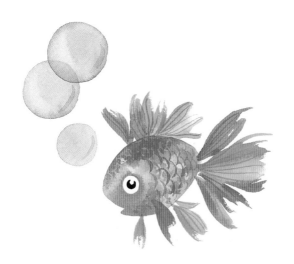

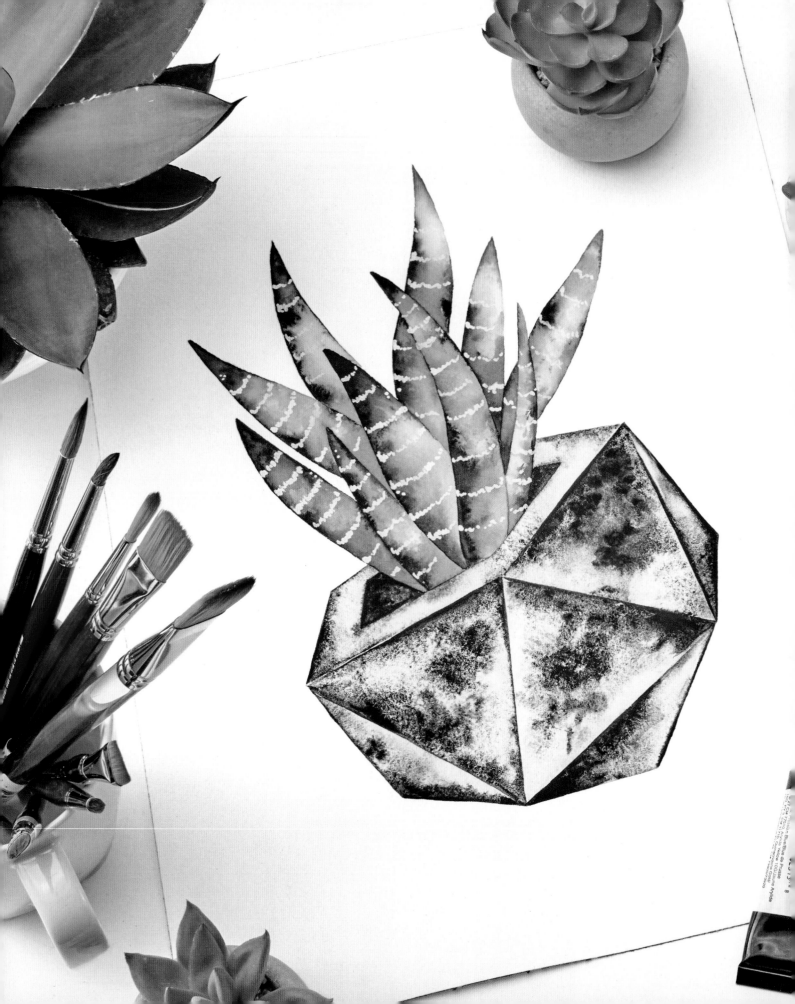

Hello, Watercolor!

Creative Techniques and Inspiring Projects for the Beginning Artist

Jeannie Dickson

Get Creative 6

New York

Get Creative 6

An imprint of Mixed Media Resources
19 West 21st Street
Suite 601
New York, NY 10010
Connect with us on Facebook
at facebook.com/getcreative6

Senior Editor
MICHELLE BREDESON

Art Director
IRENE LEDWITH

Production
EMBASSY GRAPHICS

Chief Executive Officer
CAROLINE KILMER

President
ART JOINNIDES

Chairman
JAY STEIN

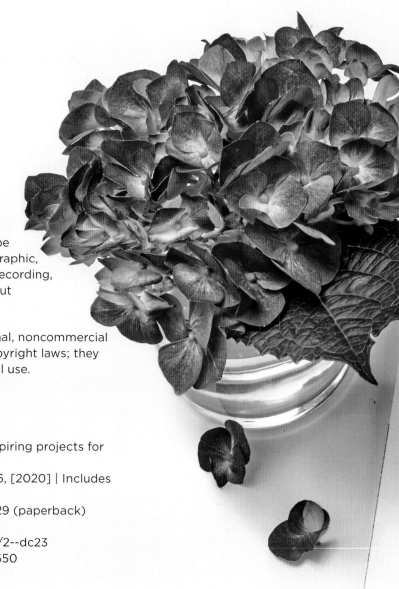

To my best friend and the love of my life, David, and to the two greatest joys of my heart, Alessandra and Eliana. Thank you for letting me take over the dining room table so I could make art.

Library of Congress Cataloging-in-Publication Data

Names: Dickson, Jeannie, author.
Title: Hello, watercolor! : creative techniques and inspiring projects for the beginning artist / Jeannie Dickson.
Description: First edition. | New York : Get Creative 6, [2020] | Includes index.
Identifiers: LCCN 2019050650 | ISBN 9781684620029 (paperback)
Subjects: LCSH: Watercolor painting--Technique.
Classification: LCC ND2420 .D53 2020 | DDC 751.42/2--dc23
LC record available at https://lccn.loc.gov/2019050650

Manufactured in China

7 9 10 8 6

First Edition

Acknowledgments

Special thanks to God for hearing my prayers and for giving me the ability, skills, and creativity to make art from the heart. To my husband, David, for all your advice and for keeping our girls busy so I could write and paint! To my girls for being patient with Mommy and for sacrificing playdates and visits to the park and the pool so I could do book stuff! To my parents, Mayra and Fernando, who taught me to persevere and to always do my best. Finally, thanks to everyone on my publishing team for helping me navigate through the wonderful world of book writing.

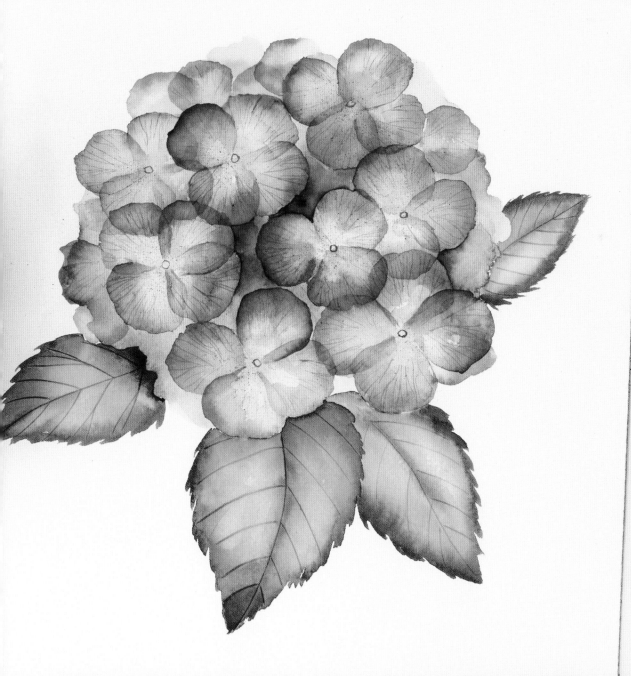

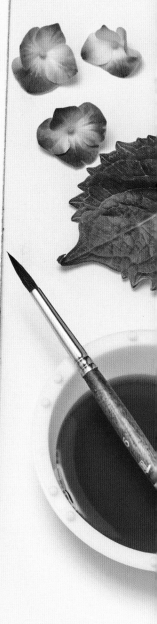

Contents

The Wonders of Watercolor

In a world filled with technology, there is a yearning to return to the simplicity and timeless beauty of the handmade. Something that is tangible, an expression of what is in the heart. It's no surprise then that watercolor, with its mesmerizing and spontaneous qualities, is capturing the attention of artists around the globe. Many are falling in love with this medium, not only because it produces stunning art, but also because of the creative process, which has the power to stimulate the senses!

The Unique Qualities of Watercolor

The way color and light interact is what sets watercolor apart from any other medium. Watercolor's translucent quality allows light to bounce off the white of the paper and reflect back to the viewer, passing through layers and layers of luminous watercolor paint!

When you think about it, you have two very powerful elements—water and color—in one neat little package. By nature, water is dynamic. It transmits freshness, movement, strength, and life! It's capable of creating a sense of calm and peace, but at the same time can be forceful and unpredictable.

Color can have a great impact on how you see the world. Color can alter your mood. When you look upon a green field, you feel a sense of tranquility because of the impact the color has on your brain, and in turn, your emotions.

Learning to use these two elements together is possible! But like everything in life, in order to get anywhere, you need to invest time and effort. Learning about the tools, materials, and techniques will help you succeed in your artistic pursuits.

The Hows and Whys of Watercolor

When I first began experimenting with watercolors, I didn't really know the ins and outs (or should I say the hows and the whys) of watercolor. I just painted for the fun of it! The more I painted, the more I fell in love with the medium. I used every available moment to paint. And because watercolor is such a forgiving medium, it allowed me to be playful even when I didn't know much about it. But the more time I spent with it, the more I realized watercolor could offer so much more! And so could I, if I only applied myself. This superficial dabbling with the medium turned into a full-blown passion that drove me to want to learn everything about watercolor.

The more time you spend with watercolor, the better you, too, will understand the hows and the whys. By learning some basic techniques, you will be able to use time as an ally to create the effects you desire. By learning about color relationships, you will use them to your advantage, giving you the ability to create an endless number of color combinations you can apply to your work.

Challenging Yourself

As you paint, you will undoubtedly find techniques and themes that come easily to you, but the more you challenge yourself, the more you will learn and grow. There are no shortcuts to getting really good at something, just the straight and narrow path of dedication, passion, and hard work. But when there's passion, you will find a way. The long hours become short, and our desks become our playgrounds.

Creative Flow

Creative flow is an incredible state of mind in which you are completely immersed in a particular task, in this case, painting. It's like a little window of time when creativity simply spills out of you like a river and you effortlessly put to work everything you know and have learned beforehand. It's not like a switch you can turn on and off. It's something that finds you when you're at the corner of working and playing. I've learned that in order to find my creative flow, I have to show up. You have to push through all the other moments when it's simply not working out. Don't give up, just show up! Perseverance is key to success!

In this book, I will walk you through some of the basic concepts and techniques that can help you grow and cultivate your love for watercolor, as well as help you get acquainted with the essential tools and materials. The projects include a wide range of subjects and levels of difficulty. Challenging, but at the same time easy enough for anyone starting out to be able to follow along and then make it their own.

From the moment you picked up this book, you decided to listen to your creative calling. Let's do this together!

Before You Start: Skills to Build

Before we take advantage of all the exciting watercolor techniques and materials that are available to us, let's take a moment to go through some basic drawing skills that can help facilitate your painting experience.

Observation

Observing and looking are two different things. For example, how many times have you seen your coffee maker, used it, made great coffee with it? If I asked you to draw it from memory though, would you remember every detail? That is exactly the difference between seeing and observing. Instead of just looking, we need to take a step further and observe all the tiny little details that make up our subject so we can then capture it on paper. When we observe, we gain information. Once you have this information, it is up to you to find out what you will do with it. Any ordinary subject can become your next source of inspiration!

Sketching

Sketching is a great place to start. It's freehand, it's quick, it's spontaneous, and there aren't many details involved. Sketching might be scary for many beginners, but the more you practice, the easier it will become. Turn on some music, pick up a pencil, observe, and try to capture your subject. Start with the largest shapes, then fill in details. Look at the angles of the lines and try to replicate them in your sketch. Draw quickly, without any fear or hesitation. Quick and light strokes are best. It might not look like a perfect photocopy of your subject, but that is not important. These rough lines can later be polished and perfected if that's your goal.

Precision

This is a skill that has helped me tremendously throughout my artistic career. When I was in college, I took a drawing class in which we spent long hours filling pages with simple lines. I didn't know it at the time, but these repetitive exercises were giving me a powerful skill: the ability to draw clean, precise lines and shapes. You don't need any complicated tools to get started, just a pencil and paper. Start with the exercises on the opposite page.

Doodling

Doodling is a great way to stimulate our creativity when creativity is nowhere to be found. These are simple drawings that are sometimes done unconsciously or without much focus. Sometimes we doodle simply to pass time, but the experience can be soothing and can help you decompress after a long day.

I've noticed that even though I'm not "thinking" about what I'm doodling, the experience is very relaxing. As a busy mom, I don't always have time to sit down and doodle, but I've made a point to carry a little drawing pad and a couple of pencils in my handbag so I'm always ready in case the opportunity presents itself. Sometimes I will even keep my doodles so I can use them as inspiration for future paintings. Remember, there are no rules for doodling, so let loose.

Exercises

For these exercises you'll need a sketchpad or any type of copy or printer paper and a pencil.

As you do these simple exercises, you acquire the fine motor skills needed to create freely. This is very important when painting loose, abstract paintings. You will feel comfortable making your brush dance in every direction, allowing you to stay in the flow.

LINES

Try drawing straight lines with your pencil. Straight lines in all directions. Short lines and then long lines. Draw lines between the lines. Don't worry if your lines are shaky at first; you will develop control as you practice.

CIRCLES

Next try drawing circles in different sizes. Draw circles within circles and circles outside of circles. It's hard to draw a perfect continuous circle on your first try, so instead

draw short, soft lines to build up your circle and then trace over it with a bolder line.

SHAPES

Draw a variety of shapes and quickly fill them in with your pencil, trying to stay inside the lines. Next, try filling them in with different shades, meaning make some light, some dark, and some in between. This will help you learn how to control the amount of pressure you're using when filling in your shapes as well as helping you focus on staying inside the lines.

Keep Practicing

Today's practice will always be better than yesterday's. Make time each day to work on these skills, and they will help you build your confidence as an artist. There are so many wonderful resources that can help you improve your drawing skills, and it is never too late to get started. The important thing is to have a desire to learn and a positive attitude.

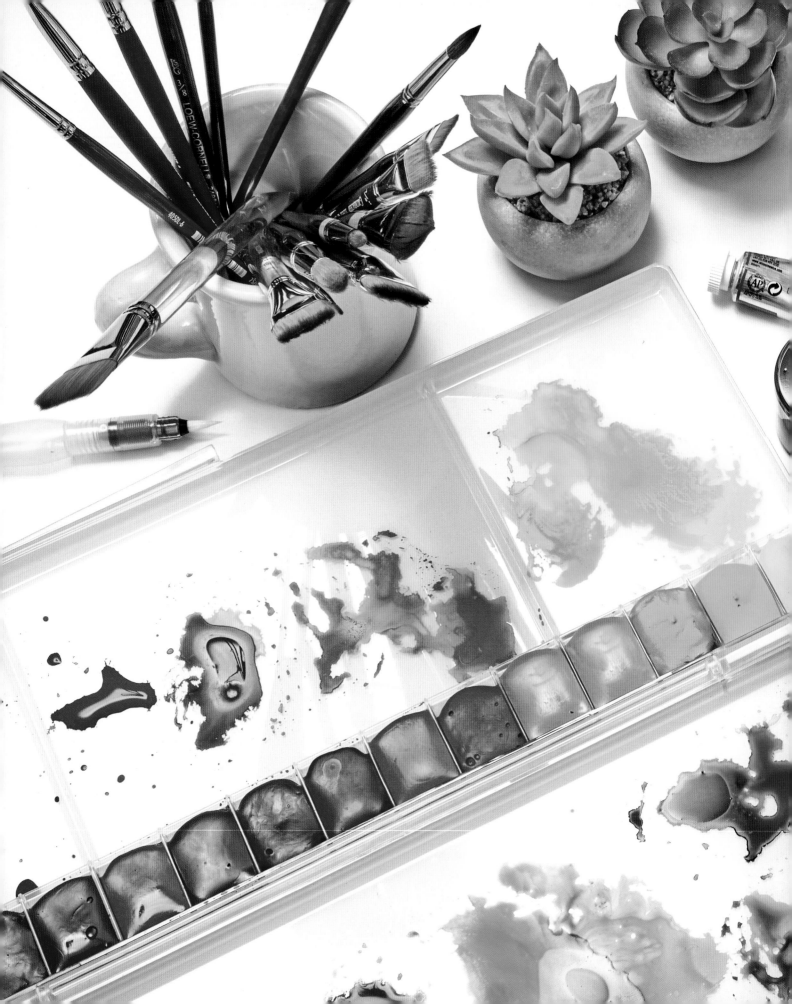

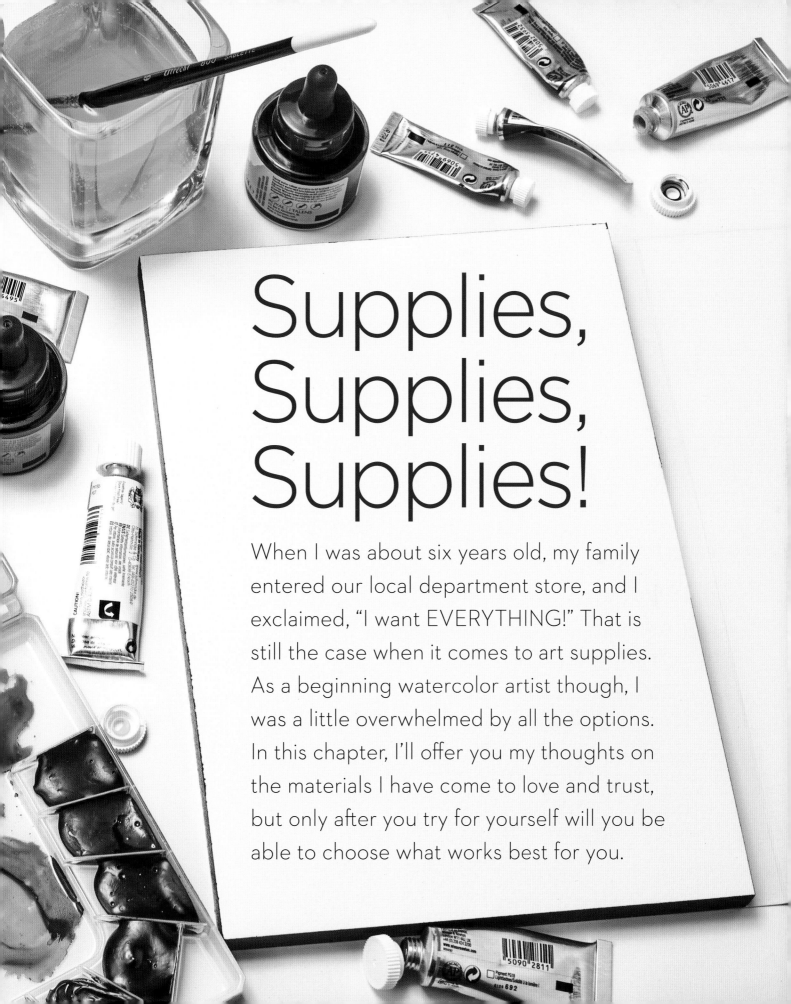

Supplies, Supplies, Supplies!

When I was about six years old, my family entered our local department store, and I exclaimed, "I want EVERYTHING!" That is still the case when it comes to art supplies. As a beginning watercolor artist though, I was a little overwhelmed by all the options. In this chapter, I'll offer you my thoughts on the materials I have come to love and trust, but only after you try for yourself will you be able to choose what works best for you.

Paper

To get started with watercolors, you'll need six essential supplies: paper, brushes, paints, a palette, water, and paper towels. The first we'll look at is paper. Even when you're just starting out, the paper you use will have a big impact on your progress. You don't necessarily have to use top-of-the-line paper, but there are some variables you should keep in mind.

Paper Grades

There are two paper grades: artist (also called professional) grade and student grade. I used student-grade paper when I first started painting because I didn't want to spend a lot of money. As my painting progressed, I realized I was missing something my student-grade paper couldn't provide. When I got my first pad of artist-grade watercolor paper, I found that paper does make a big difference. The pigments seemed to interact more naturally, and my blends came with less effort.

Inexpensive paper has a place and a purpose. For example, I use cheap paints and paper to practice different brushstrokes. When I feel confident, I then transition to the more expensive paper.

Whatever you decide to use, consider these key factors when choosing your paper.

ARTIST GRADE

This type of watercolor paper is 100-percent real cotton. There are many brands available to artists, and it usually comes down to personal preference.

STUDENT GRADE

Student-grade paper is inexpensive and can be easily found at your local art-supply store. Many of these are made of wood pulp or a combination of cotton and cellulose fibers, rather than 100-percent cotton.

Form

Watercolor paper is available in sheets, rolls, pads, and blocks. For beginners, I recommend pads or blocks because they come precut in different sizes. I prefer blocks because the paper is already glued on all four sides so I don't have to stretch it. Once my painting has dried, I use an old credit card or a thin ruler to carefully separate the sheet from the block. For the projects included in this book, we will use mostly 9" x 12" (22.9 x 30.5cm) and 10" x 14" (26 x 36cm) size sheets or blocks.

TO STRETCH OR NOT TO STRETCH

If you use loose sheets of paper rather than blocks and you're planning to use a lot of water in your paintings, consider taping your paper down on all four sides so it won't buckle too much. You can also stretch it. Look for tutorials online on how to stretch paper.

Weight

The thickness of watercolor paper is indicated by its weight, measured either in grams per square meter (gsm) or pounds (lb) per ream (500 sheets). The main thing to remember when choosing paper is that thicker (heavier) paper can handle more water or paint without warping. The most common weights are 190gsm (90lb), 300gsm (140lb) and 640gsm (300lb). My favorite weight is 300gsm (140lb).

Texture

Watercolor paper is available in three textures or finishes: hot, cold, and rough.

HOT PRESS

The term "hot press" refers to the method of pressing watercolor sheets between heated rollers at high pressure, giving them a smooth finish. Out of the three, it is the least absorbent and can be a bit slippery, making it hard to control the water and paint. But it's great for fine-detail work such as pen and ink and lettering.

COLD PRESS

"Cold press" again refers to its manufacturing process. In this case, paper is pressed through felt-covered rollers at cold temperatures. Often referred to as NOT paper, meaning it is "not hot pressed," cold press is the most versatile and popular watercolor paper. It has a semi-rough texture, or what artist like to call "a little tooth." It is considered the easiest watercolor paper to work on.

ROUGH

As you might expect, rough is the most textured paper available. It features a very textured tooth that is good for washes and especially for expressive painting techniques.

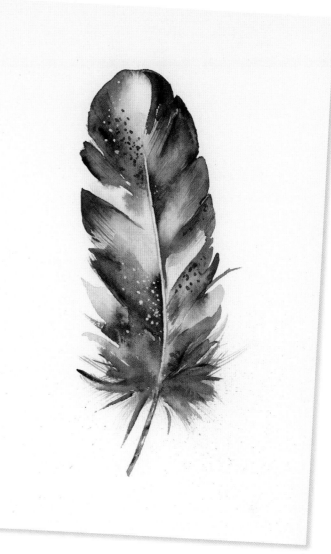

Cold-press 100-percent cotton rag watercolor paper is my favorite. It provides a beautiful textured surface and has a high absorption capacity.

I don't recommend it for detailed work due to its bumpiness.

Acid Free

When shopping for watercolor paper, it is of the utmost importance to make sure your paper is *archival*, or acid free. Paper that isn't acid free tends to become yellow and brittle over time.

Brushes

Don't you love the feeling of a well-loved pair of sneakers? Ones that perfectly fit your needs and that you can rely on? That's the feeling I get when I pick up my favorite brushes. I went through several brands and types and finally found the ones that work best for me.

The Parts of a Brush

Let's take a look at the anatomy of a brush.

TIP

This is the part used to draw and release the paint. It is the most fragile part of the brush. Brushes can be a bit pricey, so be careful to protect the tip to prolong the life of the brush.

BELLY

This is the middle part of the hairs on the brush that serves as a paint reservoir. It contains all the pigment that has been loaded onto the brush, ready to be released through the tip. Wider bellies hold more paint.

FERRULE

This is the metal part of the brush that holds and connects the hairs to the handle of the brush. A good quality ferrule is made out of a single piece of metal without a seam.

HANDLE

The handle is typically made from wood and has a coating of protective paint. Here is where you will find printed information about the brush, such as its brand and size.

Hair Type

The price of the brush will depend greatly on the type of hair.

NATURAL HAIR

SYNTHETIC

BLENDED

NATURAL HAIR

Sable-hair brushes, specifically Kolinsky sable (a species of mink), are considered the best for watercolor. This type of brush can be very expensive. Brushes can also be made from other animal hair, such as squirrel and goat.

SYNTHETIC

These brushes are made from nylon or polyester filaments and are designed to mimic the performance of natural hair but at a much lower cost. They tend to hold less water and are stiffer than natural hair brushes. Since the bristles of these brushes have a little more spring to them, you might find them easier to control.

BLENDED

Brushes that are a blend of natural and synthetic hair perform well at an affordable price. They hold plenty of water and release it smoothly.

TIP

BELLY

FERRULE

HANDLE

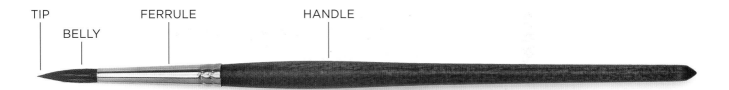

CARING FOR YOUR BRUSH

A new brush is usually stiff because the bristles have been dipped in a solution of gum arabic to bind the hairs together and protect them during transportation. To remove this coating, dip the brush in water then let it sit on a paper towel for a few minutes. Repeat until the brush is soft. Don't bend it: You might damage your beautiful new brush! After painting, rinse your brush and set it down on a flat surface to dry before storing it in an upright position. Don't leave your brush in the water because it can ruin the tip of the brush and cause the paint on the handle to peel off! To clean very dirty brushes, use a mild soap or brush cleaner. Rinse your brush in warm water and gently lather. Rinse and repeat as necessary. Shape the tip of the brush to a point and let dry.

Shape

Brushes also come in different shapes. The most common are flat and round. Here are some different shapes and their uses:

Flat: With a flat ferrule and square end, it's perfect for architectural painting or covering large areas.

Liner: A very thin brush that's great for outlining and making thin, long strokes.

Filbert: The soft, rounded edge is perfect for blending.

Round: The most versatile shape, it has a round ferrule and can create thick and thin lines. These are my favorite!

Wash/Mop: These large brushes work well for laying paint or water across large areas.

Water brushes: These brushes have a reservoir of water attached to the brush. You control the flow of the water by squeezing the barrel. They're great for painting on the go.

Size

The size of the brush is indicated by a number printed on the handle. They start at 000 and then go to 00, 0, 1, 2, and up. The higher the number, the wider the brush. There can be a little inconsistency in size, so be careful when buying online.

Large brushes are good for covering large areas, while smaller brushes are good for smaller areas or detailed work. If I was able to purchase only one brush, I would choose a size 8. Other recommended sizes are 2, 10, and 12.

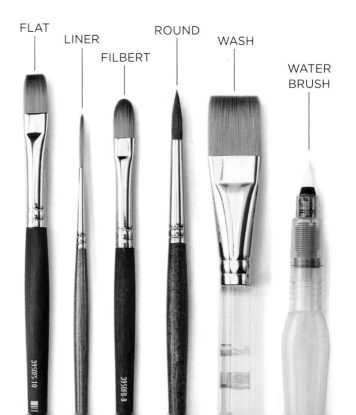

FLAT LINER FILBERT ROUND WASH WATER BRUSH

Paints

Watercolor paint is a mixture of finely ground pigment, or colored powders, suspended in a water-soluble medium, such as gum arabic. These pigments can be made from natural or synthetic materials and are what give the paint its color. My personal watercolor palette has changed and will continue to change over time. It's like a never-ending adventure of discovering colors that can help me express what is in my heart. Here are some things to consider when choosing paints.

Grades

Professional-, or artist-, grade paints have the highest quality pure pigments, resulting in clean, vivid colors. Student-quality paints have artificial fillers to make them more affordable, but they can be dull.

Every color is made from one or more pigments. This pigment information is usually on the label. It will include the pigment code and a number that specifies the exact chemical compound in the paint. There are ten codes: PY (pigment yellow), PO (pigment orange), PR (pigment red), PV (pigment violet), PB (pigment blue), PG (pigment green), PBr (pigment brown), PBk (pigment black), PW (pigment white), and PM (pigment metal). For example ultramarine blue is PB29.

Some colors are made from multiple pigments, so keep this in mind when mixing these types of paints, because the result may be dull and lifeless. Single-pigment paints can give you more control when mixing.

Don't worry you'll have to break the bank buying paints when you first start out. In the next chapter, we will talk about the limited color palette of only six colors you can start with.

Permanence

Permanence refers to the lifespan of a pigment. A "fugitive color" is one that can become lighter or darker when exposed to certain environmental conditions such as sunlight and humidity. If you want your paintings to last, select colors that have a high lightfast rating. Ratings go from I (excellent) to IV (fugitive). When painting just for fun, permanence might not be a big issue, but if you're planning to sell your artwork, consider using pigments that have the best archival quality.

Form

Paints come in three forms: pans, tubes, and liquid.

PAN PAINTS

Pan paints are sold individually or in sets that are convenient and work great for painting *en plein air* (outdoors) or when traveling.

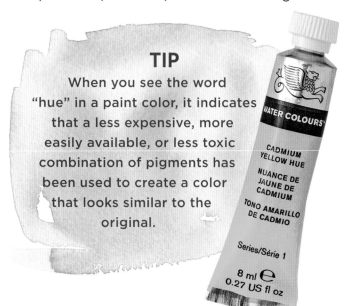

TIP
When you see the word "hue" in a paint color, it indicates that a less expensive, more easily available, or less toxic combination of pigments has been used to create a color that looks similar to the original.

EXPLORING OPAQUE WATERMEDIA

Although some watercolor artists strictly use transparent watercolors, others incorporate opaque watermedia, such as gouache, acrylic, or casein, to achieve different effects. These water-soluble mediums can be used on their own or combined. Watercolor and gouache work especially well together because, after all, gouache is simply an opaque watercolor. I like to use gouache for final details in a watercolor painting; however, I have created pieces using just gouache. Give these different media a try! They can open a whole new world of possibilities.

Gouache really pops on black watercolor paper.

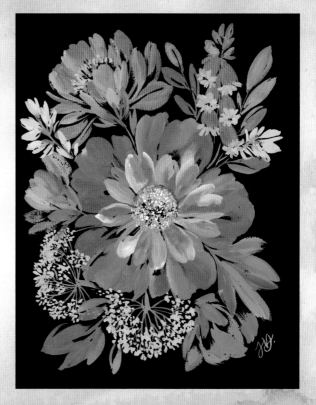

TUBE PAINTS

I prefer to purchase watercolor paints that come in tubes so I can use them to create my own custom color palette.

LIQUID WATERCOLORS

Most liquid watercolors, or watercolor inks, are made with dyes. Since dyes are completely water soluble, they bind directly with the watercolor paper and will stain your paper almost instantly. Also liquid watercolors are not lightfast; those vibrant colors can fade over time. I love using liquid watercolors for brush lettering (see Chapter 4, Brush Lettering Basics).

In the next section, we'll look at properties of watercolor paints, which will help you in choosing paints to buy and try.

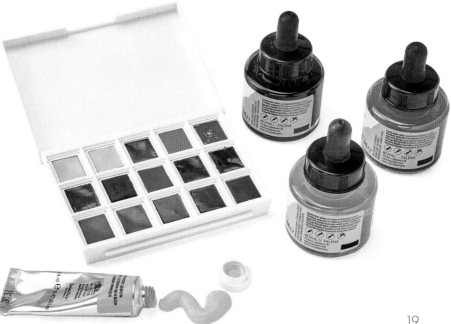

Properties of Watercolor

Before you invest in watercolors, get to know the properties that make watercolors so unique. This will help you choose paints that achieve the effects you are going for and avoid undesired surprises!

Transparency and Opacity

One of the most important characteristics of watercolor is transparency. You can achieve a luminous watercolor piece that almost seems to glow by allowing the white of the paper to shine through your paints!

After the water has evaporated, transparent paints allow the greatest amount of light to pass through to the paper and reflect back to the viewer, creating that beautiful luminous effect. Transparent colors remain transparent when mixed with other transparent colors.

While truly opaque watercolors are called gouache, which is a different medium (see Exploring Opaque Watermedia on page 19), some watercolors are more transparent than others. More opaque pigments are thicker and allow less light to pass through. When mixed together these colors can become muddy.

Manufacturers usually specify if a paint is transparent, opaque, or somewhere in between, but you can also determine it yourself (see below).

Transparent watercolors (the swatches near the top) allow for a technique called glazing, in which colors are layered on top of each other, creating new colors (see page 50). More opaque watercolors (bottom) don't allow other colors to show through as much.

Draw a long horizontal line with a permanent black marker on a scrap piece of watercolor paper, allow it to dry, and paint short vertical strokes on top. If the paint appears to be "behind" the black line, it is a transparent paint. If the paint appears to be "in front of" the black line, you have an opaque paint.

Staining or Non-staining

Some pigments stain your paper, meaning you won't be able to completely lift or blot out a color once applied.

To test your colors for staining, paint a little swatch, allow it to dry, and then, with a stiff, damp brush, gently "scrub" a section. Don't scrub too hard or you might ruin your paper! If you can get back to the white of the paper, this means your paint is non-staining or "liftable." If the paper still has a little tint or color, the paint is staining.

Granular or Smooth

Granulating paints have bigger pigment particles that will collect and sink to the valleys (or little grooves) of the watercolor paper and create a grainy appearance. The more water you use, the more granulation you will see. The finer the pigment particles, the less they granulate and the smoother the paint will appear in a wash (see page 44).

Granulation is a fascinating characteristic of watercolor because it creates instant visual texture. Some paints include natural earth pigments that have larger particles and granulate beautifully.

Granulating (left) and smooth (right) watercolors.

Palettes

If you're planning to purchase tubes of watercolors, you will need a palette on which to squeeze your paints. I like one with medium to large wells (indentations), so I can easily load paint with my brush. I also prefer palettes with large mixing areas.

Palettes come in different sizes and materials, such as plastic, ceramic, and aluminum with baked-on enamel. Some are portable and come with a lid you can open and close. I like ones I can close when not in use to protect the paint from dust.

Something to keep in mind when purchasing a plastic palette is that paint tends to "bead up" or separate into little beads of paint, and it will be harder to see the color of your mixes. You can help prevent beading by rubbing the surface with the rough side of a sponge and washing it with mild soapy water. Another solution is to mix your colors on a white ceramic plate. White ceramic is really the best mixing surface for paints as you can clearly see the colors you're mixing.

Arranging Your Colors

Now that you have selected the paints and palette, you're ready to squeeze your paints! I know, it's an exciting time, but let's slow down and talk about how you can arrange your colors.

Choose a palette that holds all your favorite colors and has plenty of room for mixing.

When first setting up your palette, I recommend you dedicate one side to warm colors, such as yellows, oranges, reds, and pinks, and the other side to the cool colors, such as greens, browns, blues, and purples.

Once you have decided on the order of your paints, place the tubes on top of the wells and take a picture. Sometimes it is hard to identify the color as it may look very dark once the paint has dried.

Filling the Wells

Squeeze the paint into your well and smooth it out with a toothpick. If you don't, the paint will dry all bumpy, making it harder to load your brush. Allow them to dry for at least 24 hours.

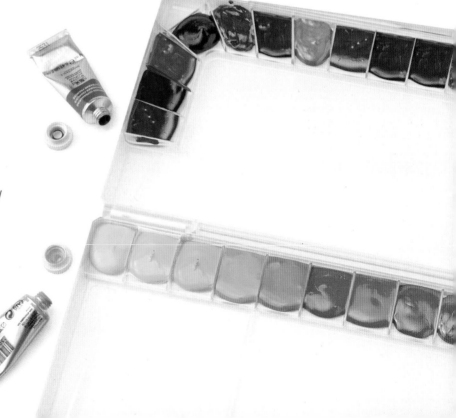

Nonessential Materials

In addition to paper towels and a jar for water, there are a number of items you will probably want to add to your watercolor toolbox over time.

- **Mechanical pencil:** I use one with an HB lead for sketching and tracing designs.
- **Eraser pen:** Perfect for precision erasing.
- **Kneaded eraser:** Use this to lighten sketches before adding watercolor.
- **Spray bottle:** Used to moisten paints on the palette as they dry out.
- **Painter's soap:** Helps with cleaning extra-dirty brushes.
- **Ruler:** For drawing when straight lines are needed.

- **Heat tool:** Use this to speed up the drying process.
- **Tracing paper:** This is a great tool for refining sketches and compositions.
- **Masking fluid:** See page 51 for tips on masking techniques.
- **Sketchpad:** Keep one handy for sketching and designing compositions.
- **Lightpad:** Use one or a window for tracing templates (see page 132).
- **White ceramic plate:** A smooth, neutral surface for mixing colors.

Your Workspace

Now that you have all your supplies, it's important to designate a space where you can work comfortably.

My studio is a cheerful, organized place where I can immerse myself in painting.

Ideally, sit by a window with lots of natural light. If this isn't possible, try to use a good arrangement of artificial lights with bulbs that mimic natural light—nothing too warm or too cool as that will affect how you see color.

Use a nice, sturdy table where you have enough space to spread out your supplies. If you're right-handed, place all your painting materials to your right and vice versa if you're left-handed.

Most important, choose a space where you will gladly spend a few hours painting!

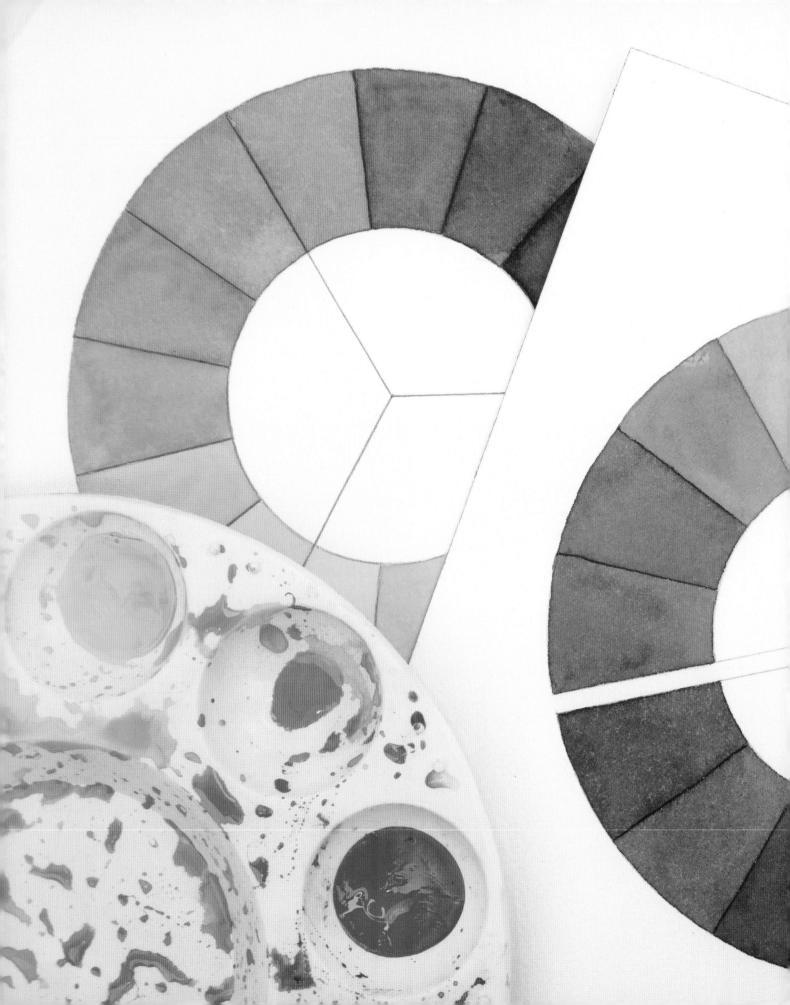

Getting to Know Hue

You now have your supplies and are ready to start painting! But before you jump into creating your masterpiece, take a little time to learn more about color and how it relates to watercolor. After all, the luminous colors you can achieve with watercolor are the main appeal of this medium for most artists. Having a grasp of simple color theory will open up so many possibilities for mixing custom colors, combining colors harmoniously in your paintings, and making your paint budget stretch.

Color Theory 101

To paint effectively, it's important to have a good understanding of color theory. Knowing these basic principles frees us to paint and stay in the creative flow. We can mix any color we like without having the frustration of not knowing why a certain color is not giving us the results we want.

Primary Colors

Red, yellow, and blue are called *primary* colors because we can't mix other colors to create them; however, they can be mixed to create all the other colors in the spectrum.

Secondary Colors

We obtain the secondary colors—orange, green, and violet—by mixing two primaries.

Tertiary Colors

Yellow-green, blue-green, blue-violet, red-violet, yellow-orange, and red-orange are the tertiary colors. We create each of these by mixing a primary and a secondary color.

Twelve-Hue Color Wheel

A traditional color wheel consists of twelve hues (colors) arranged in a circle according to their relationship to one another. It is based on the three primary colors from which you can obtain your three secondary and six tertiary colors. Selecting the "right" primary colors can be a little tricky so I encourage you to keep reading and learn how to use a split-primary color wheel, which uses two sets of primary colors.

Warm and Cool Primaries

The warmth or coolness of a color is relative to where a color falls on the color wheel.

When creating our own mixes, we need to be aware that the primary color paints that are available to artists are not "pure" primary colors. Each primary color will always tend to lean toward one of the other primaries, meaning you will always find at least two versions of each primary color: a warm and a cool version.

Red and yellow are considered warm colors. Blue is a cool color. But as mentioned before, each primary color has a warm and a cool version, so in order to know which colors are best mixed together, we will carefully select the two primaries—the "parent" colors—that already have a close relationship to each other.

TWELVE-HUE COLOR WHEEL

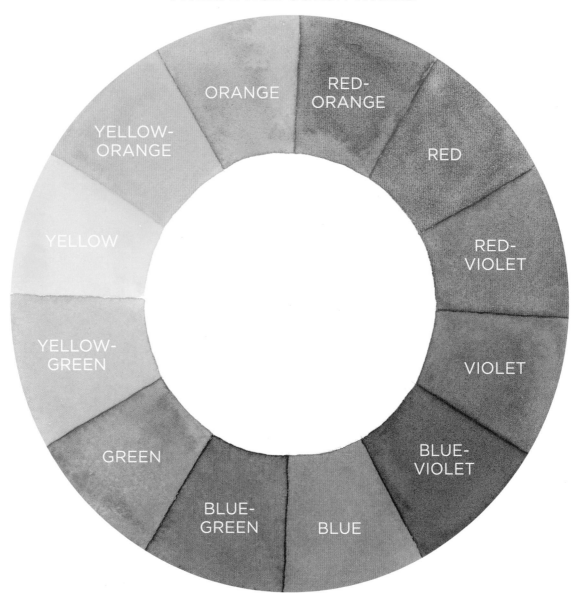

ORANGE

RED-ORANGE

YELLOW-ORANGE

RED

YELLOW

RED-VIOLET

YELLOW-GREEN

VIOLET

GREEN

BLUE-VIOLET

BLUE-GREEN

BLUE

WARM AND COOL PRIMARIES

Warm yellow (left) leans toward red. Cool yellow (right) leans toward blue.

Warm red (left) leans toward yellow. Cool red (right) leans toward blue.

Warm blue (left) leans toward red. Cool blue (right) leans toward yellow.

Split-Primary Color Wheel

Instead of the traditional twelve-hue color wheel mentioned earlier, the split primary wheel works with fifteen hues that are divided into three equal sections. Each section will contain one set of parent colors and their resulting mixes.

You know the phrase "less is more." Well, this perfectly describes my experience with color. When I first began painting with watercolors, I thought I needed to purchase all the colors out there! No matter how many I bought, I always felt like I didn't have the "right" colors.

I realized the problem wasn't my lack of color options, but that I needed to learn where colors came from, and how I could reproduce them. I chose six colors, two sets of primaries, and learned how to mix them. Using a limited palette has been a great learning experience.

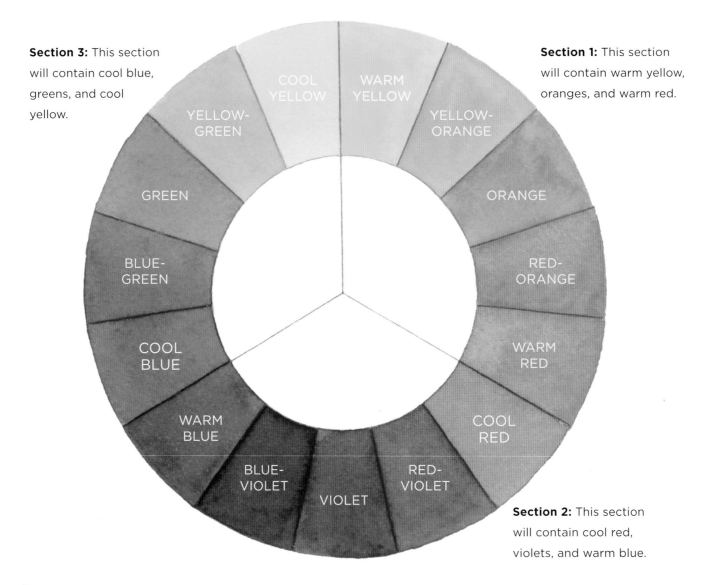

Section 3: This section will contain cool blue, greens, and cool yellow.

Section 1: This section will contain warm yellow, oranges, and warm red.

Section 2: This section will contain cool red, violets, and warm blue.

Creating Your Own Color Wheel

You can learn a lot by reading about color and color mixes, but you will really learn when you actually sit down and do it yourself. Don't skip this step; you will see that this is a very enjoyable process!

Here is a list of six parent colors you can use for this exercise.

Lemon (cool yellow)
Yellow deep (warm yellow)
Pyrrol scarlet (warm red)
Permanent rose (cool red)
Blue (red shade) (warm blue)
Blue (green shade) (cool blue)

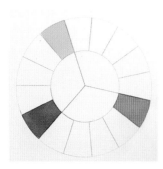

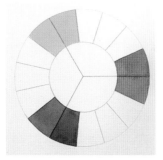

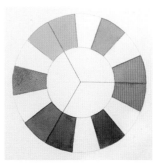

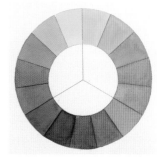

1 Paint the cool version of each primary color: permanent rose, blue (green shade) and lemon yellow. Place them as shown.

2 Next, paint the warm version of each primary: yellow deep, pyrrol scarlet, and blue (red shade).

3 Next, mix the two primary parent colors from each section to create your secondary colors, green, violet, and orange. Paint these equidistant between their two parent colors.

4 Finally, mix each secondary color with one parent primary to create your tertiary colors. Place each new color between the two of them.

Color Formulas

Here are a few formulas that can help you create clean, vibrant secondary and tertiary colors. When mixing colors, start with the lighter color and add the darker color a little bit at a time.

Secondary Colors:
Warm yellow + warm red = Orange
Cool blue + cool yellow = Green
Cool red + warm blue = Violet

Tertiary Colors:
Warm yellow + orange = Yellow-orange
Warm red + orange = Red-orange

Cool red + violet = Red-violet
Warm blue + violet = Blue-violet
Cool blue + green = Blue-green
Cool yellow + green = Yellow-green

Note: We need to be aware of which version of primary colors we're mixing because we might inadvertently mix complementary colors (see page 33). When mixed together, complementary colors cancel each other out, and colors lose their intensity. This isn't necessarily a bad thing. Sometimes we want our colors to be less bright with more of an earthy look.

Three Properties of Color

When we talk about color, there are three properties we need to look at: hue, value, and saturation.

Hue

Hue is the name of the color itself regardless of its other properties:

Primary hues: Yellow, red, and blue.

Secondary hues: Orange, violet, and green

Tertiary hues: Yellow-green, blue-green, blue-violet, red-violet, yellow-orange, and red-orange

Value

Value is the lightness or darkness of a color regardless of its hue. In watercolor, we can change the value of a color by adjusting the water-to-paint ratio. We'll look at value in more detail in the next sections.

Saturation (Intensity)

Saturation, or intensity, is the brightness or dullness of a color. A color is most saturated, or intense, in its purest form. Intensity is measured as high or low. You can change the intensity (make it less intense, or duller) of a color by adding a bit of its complementary color (see page 33).

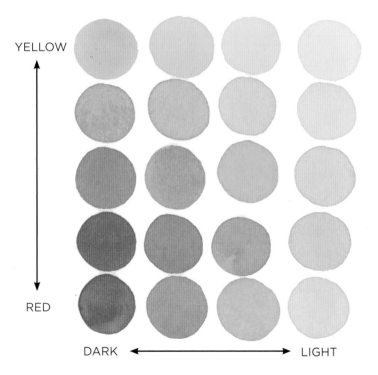

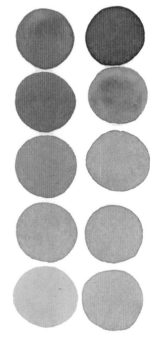

In this example, we gradually go from yellow to red, starting at the top. As we add a little of the red to the yellow mixture, we change its hue and create all those oranges in between. The darkest values are in the first column.

The complement of red is green, and the complement of yellow is purple, so we add a little green to the reds and a little purple to the yellows so to desaturate them (make them duller).

Value and Color

As we just learned, value is the lightness or darkness of a color regardless of its hue, or color. Value is what gives the painting depth and three-dimensionality, so it's important to learn to manage your darks and lights! Look at this example below.

TIP
To check the different values in your painting, snap a black-and-white photo of it.

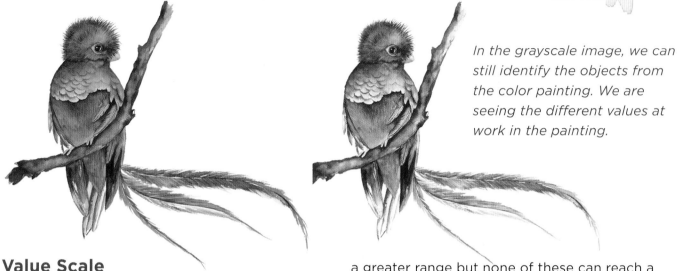

In the grayscale image, we can still identify the objects from the color painting. We are seeing the different values at work in the painting.

Value Scale

One of the best ways to become familiar with values is to use a value scale—a system of organizing values. One of the best-known is the Denman Ross Value Scale. This scale consists of nine values ranging from white to black, with shades of grays in between. Black (9) has the least quantity of light; it has the darkest value. White (1), on the other hand, has the greatest quantity of light; it has the lightest value.

In watercolor you will constantly hear the terms high lights, midvalues (or midtones), dark, etc. This scale and its terminology are easy to memorize and can help you identify the different values and their descriptions.

Value Range

It's important to know that most colors do not have a full value range from 1–9. Some colors are naturally lighter than others, for example a yellow rarely reaches 3. Red and blue have a greater range but none of these can reach a true black unless they are mixed.

Since watercolors look lighter once they have dried, it's important to know which colors have a higher value range and which don't so you can account for this when painting.

DENMAN ROSS VALUE SCALE

- *Black (9)*
- *Low dark (8)*
- *Dark (7)*
- *High dark (6)*
- *Midvalue (5)*
- *Low light (4)*
- *Light (3)*
- *High light (2)*
- *White (1)*

My Favorite Paint Consistencies

When adjusting the value of a color in watercolor, we work with different water-to-paint ratios. Dark values are obtained by using a thick consistency, or mixture, of paint, while light values are obtained by adding water.

I typically like to use three or four different paint consistencies to get striking contrasts, but you may have a different style. You might like something lighter with a more ethereal look, and that's perfectly fine, too!

A fun way to get to know your paints is to swatch all the colors you own and get to know their tonal values. You can either start with the lightest value and add pigment a little bit at a time or start with the darkest value and keep adding water to make it lighter.

The more water you add to your paint, the lighter the value will be.

Level 1

This consistency is very watery and gives the lightest values. I like to use this consistency to paint "white" elements to distinguish them from the white of the paper. It's the perfect consistency for creating soft, pastel tones.

Level 2

This is a medium consistency and gives me values in the medium range. This consistency is great for using glazing techniques.

Level 3

This consistency is thick and gives me darker values of a hue.

Level 4

This consistency is thicker and gives me strong, dark values.

Level 5

This consistency is the thickest and darkest. Using a damp brush, pick up paint directly from the wells in your palette. Lay down the color and leave it, trying not to mix and overwork it. It's great for a dry-brush technique (see page 54).

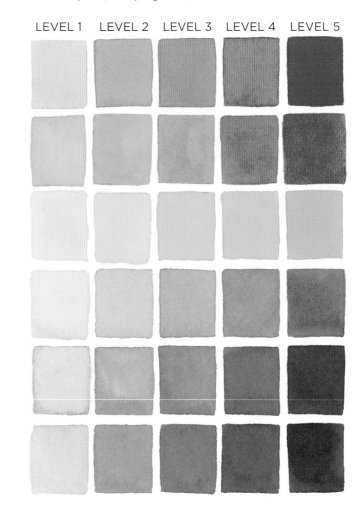

LEVEL 1 · LEVEL 2 · LEVEL 3 · LEVEL 4 · LEVEL 5

Color Harmony

Through carefully selected color combinations, we can achieve a sense of order and harmony in our paintings. These color families, like any family, have similar and contrasting features. It's good to know these relationships so colors can work together to create something visually interesting and aesthetically pleasing. Here are some popular color schemes.

Monochromatic

This color scheme is based on only one color and its different values. It is automatically harmonious, but be sure to include some value contrast so the painting won't be boring.

Monochromatic colors

Analogous Colors

These are any three or four colors that sit next to each other on the color wheel. One color is usually predominant. Since the colors are so similar, there isn't much contrast. It's a very safe color scheme but may present the challenge of creating variety and interest.

Analogous colors

Complementary Colors

On a color wheel, complementary colors sit directly across each other. Because these colors are opposites, these color schemes are tricky to use in large doses, but work well when you want something to really stand out.

Complementary colors

A quick way to remember complementary colors is that the complement of a primary color is the mix of the two remaining primaries. The complement of red is the mix of the other two primaries, in this case blue and yellow, which combine to make green. The complement of yellow is violet (red + blue), and the complement of blue is, you got it, orange, the mix of red and yellow.

Create beautiful and interesting paintings by carefully putting complementary colors next to each other without letting them mix. Choose one color to be dominant and use lighter values of the other.

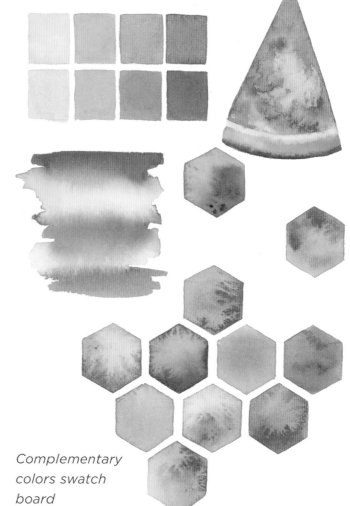

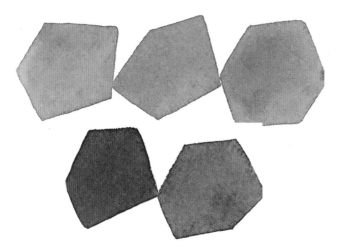

When mixed together, complementary colors can create "mud," or what I like to call beautiful earthy tones such as these.

Complementary colors swatch board

WARM AND COOL COLOR SCHEMES

Color temperature can also affect the overall feeling of a painting. Warm colors make us think of sunlight, fire, and heat and can create a sense of heightened emotion or excitement. Red is the most emotionally intense color, used to elevate people's passions, both negative and positive. Warm colors appear to jump into the foreground of a picture while cool colors appear to be more distant. Cool colors produce a sense of calm and refreshment but can also evoke a sense of sadness or loneliness. Color temperature can have a big impact in your painting, so think about the mood you want to create.

Triadic Color Scheme

These are three colors that are equally spaced on the color wheel. By using triadic colors, you can easily create harmony in your paintings. When the colors are linked by equal-length straight lines, they form a triangle.

There are four triadic color schemes:

Primary colors: yellow, red, blue

Secondary colors: orange, violet, green

Tertiary colors: red-orange, blue-violet, yellow-green

Tertiary colors: yellow-orange, blue-green, red-violet.

These color combinations are so vibrant that it's a good idea to let one color dominate and use the other two colors as accents or choose lighter values of the other two colors.

Split Complementary

This color scheme is similar to the complementary color scheme but with a slight variation. Instead of incorporating a hue and its complement, it combines a hue and the two colors on both sides of its complement. Like with complementary colors, this color scheme still provides high contrast, but because the colors are not direct opposites, there is less tension between them.

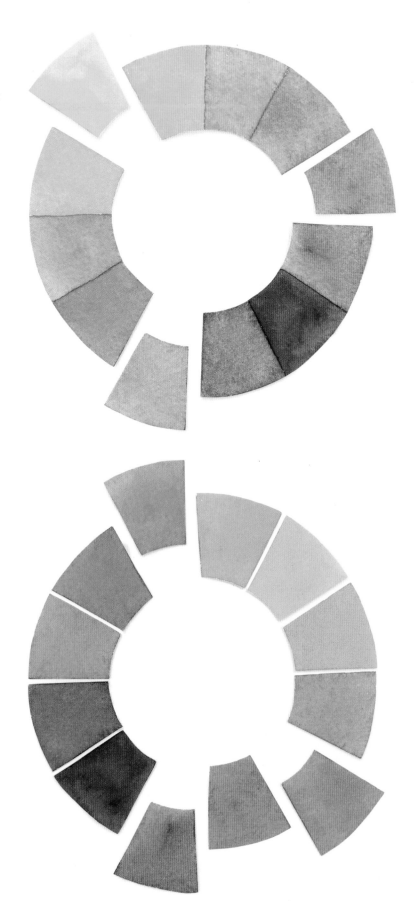

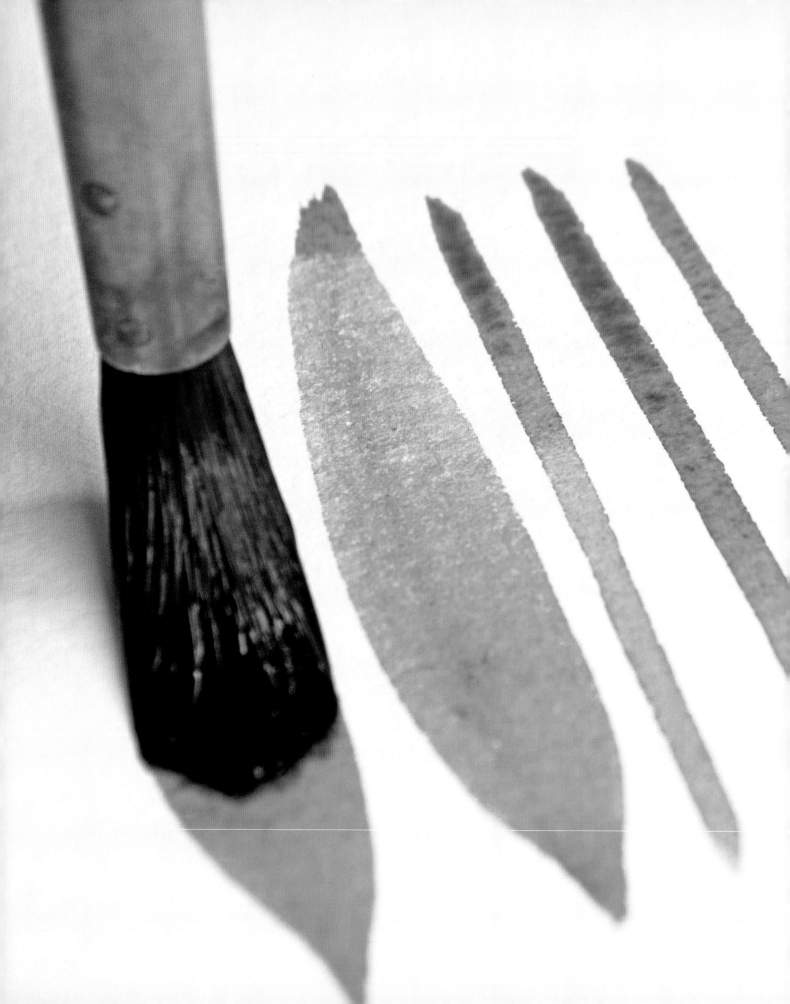

FUN-damentals of Watercolor Painting

When I first began painting, I picked up a brush, pulled out my new paints and a fresh sheet of paper, and began to paint, thinking I would create exactly what was in my mind. Of course this didn't happen. I quickly learned I wasn't going to get very far unless I took the time to really get acquainted with this fascinating medium through the study of some basic techniques. By doing this, I learned vital aspects of watercolor I can now incorporate effortlessly into my paintings and which I share with you in this chapter.

Water Control

When painting with watercolors, it's easy to fall into two extremes: You either use way too much water or not enough. To avoid this, it's important to recognize how much water is in your paper and how much water is in your brush. This is called water control.

Learning to gauge how much water is in your paper is an important skill. The easiest way to do this is to create your own scale to see what the different levels of moisture look like. I've classified the most recognizable levels as follows:

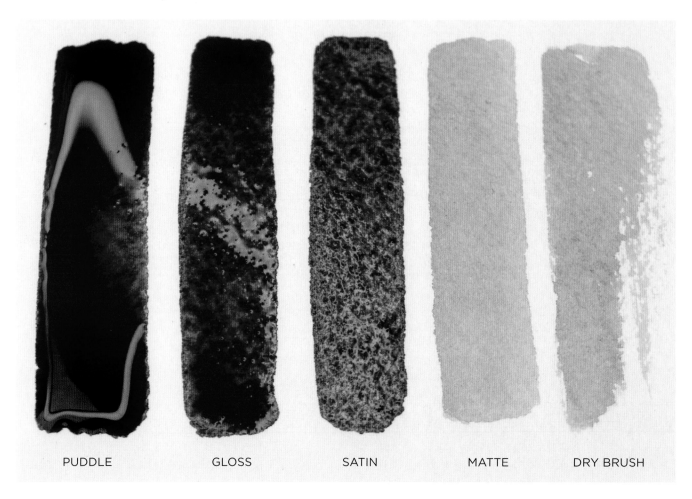

| PUDDLE | GLOSS | SATIN | MATTE | DRY BRUSH |

Adjusting Water

You can control how much water you put on the paper by adjusting the wetness of your brush. To remove excess water/paint from your brush, simply wipe it on the edge of your water jar or palette or tap the brush on your paper towel. This is something I am doing constantly when painting, so I make sure to have my paper towel on hand.

To add water or paint to your paper, simply dip your brush in your water/paint. You know the brush is fully loaded when there's a drop at the tip of your brush that looks like it's about to fall off.

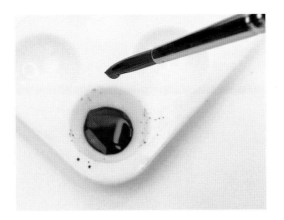

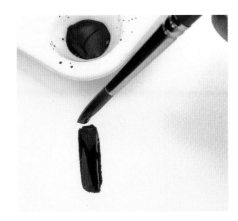

Make a mark on your paper.

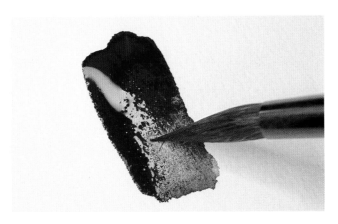

To remove or soak up water or paint from your paper, use a "thirsty" brush, one that is damp but thoroughly blotted on a paper towel. Be careful to touch only the surface of the paint and not the paper, or you will disturb the pigment already on the paper.

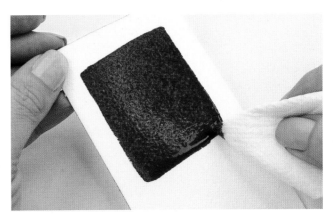

You can also use the tip of a paper towel, although that method is not as precise.

Practicing Water Control

For this exercise, we'll use only one color. I chose a violet, but you can use any color, except yellow, which is light by nature.

1. Create a watery mix with a level 1 consistency (see page 32). (You can make it darker by adding more and more pigment.)

2. Dip your size 8 brush in your watery mix, making sure to fully load your brush.

3. Create five different marks with five distinct levels of moisture from wettest (puddle) to driest (dry brush).

4. Take a moment to observe what these different levels look like.

5. Paint a shape and try to gauge its moisture level. Is it puddle, gloss, satin, matte, or dry brush?

6. Now paint another shape that has a satin moisture level.

Now try painting different shapes at different moisture levels. Do your best to do this on the first try.

Brushwork

As discussed previously under Brushes (see page 16), different types of brushes will perform differently. Natural hair brushes and blends tend to be softer than fully synthetic brushes. Synthetic brushes have a little more "spring" and are often easier to control.

I recommend you do these exercises using at least two different types of brushes so you can really see and feel the difference. Use a satin moisture level (see page 38) and a size 8 round brush.

Push and Pull

To create the various thicknesses with your brush you either pull your brush away from the paper to create the thinnest strokes, or you push your brush toward the paper to create the thicker strokes. When pulling, you're holding your brush almost vertically and painting with the very tip of your brush. When pushing, you're applying more pressure and painting with the full belly of the brush.

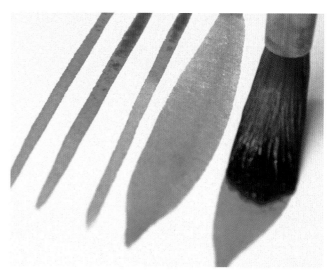

Pushing the brush toward the paper creates thick strokes.

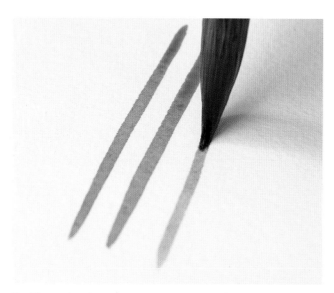

Pulling the brush away creates thin strokes.

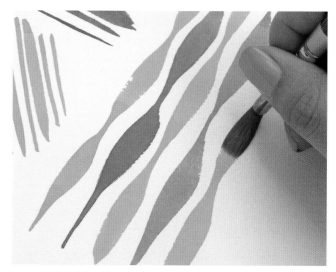

Using the push-and-pull technique, create varied lines. The orange marks were made with a synthetic brush, which works well for making straight lines. The blue were made with a blended brush, which holds a huge amount of paint and releases it with perfect control.

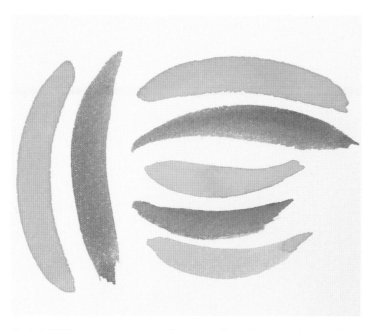

Paint "C" shapes going in one direction and then in a different direction.

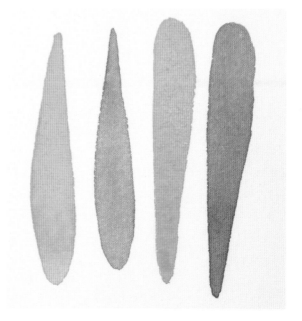

Paint a rounded stroke: In one continuous motion, paint a thin-to-thick stroke coming down, curve, and go back up, releasing pressure as you reach your starting point. Now paint another one going in the opposite direction.

Painting a Shape

Painting smooth, clean edges and corners is a skill that you need to have in your painter's toolkit. We talked about the different levels of moisture, and now you will see how understanding them can help you achieve this.

When painting straight, pointed, or rounded shapes, I've found it easiest to use a satin moisture level when getting close to the edge. If my shape is too wet, I soak up some of the excess water/paint with a clean, damp brush. I tidy up my edges and corners by gently grazing the paper with the tip of my brush. This will require precision, so keep practicing!

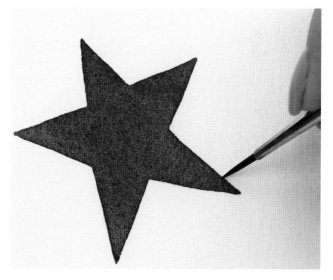

I often switch to a smaller brush to finish edges and corners.

Exercises

Okay, are you ready to begin painting some awesome shapes? I love working on my precision skills, and painting shapes with clean, sharp edges is a great way to do it.

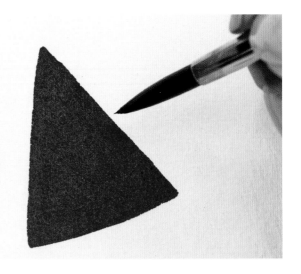

Let's begin by painting a triangle using a size 8 round brush and a watery mix. A synthetic brush will give you more control when painting straight lines.

Now paint another triangle but upside down and really close to the first one. Repeat this pattern as many times as you like, making sure to clean up your edges and corners.

Next, paint a heart and then an upside-down heart that looks just like the first one. You are now painting a shape with rounded edges, straight edges, and a corner.

Here is another exercise that can help you work on your precision skills.

TIP
For these precision exercises, it's best to use a watercolor paper that doesn't have too much texture.

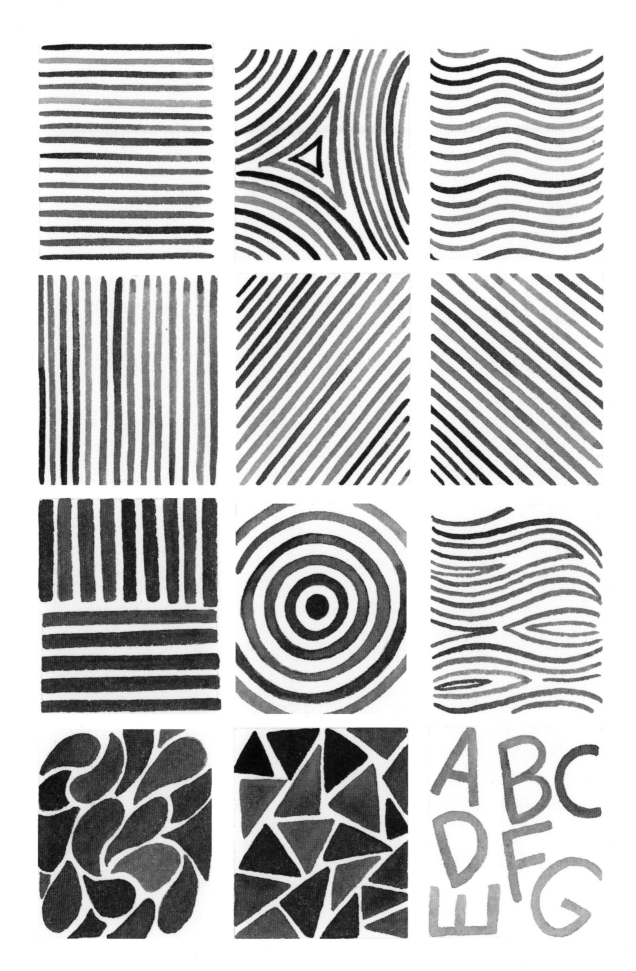

Watercolor Washes

Learning to paint washes is a fundamental part of watercolor painting, so let's put the fun into F-U-N-damental and practice creating some washes!

A *wash* is simply paint that has been diluted with water and applied in a thin and transparent layer. We can use washes to paint large areas, create skies, darken values, and much more.

There are two basic ways you can apply paint—over a wet surface (wet on wet) or a over dry surface (wet on dry). Each of these methods will give you very different results. If wet paint is applied over a wet surface, your paint will spread, causing your edges to be soft and fuzzy. On the other hand, if wet paint is applied over dry paper you will have more control because the paint will not spread, but it will produce hard, crisp edges.

There are four basic washes used in watercolor painting. Each of these can be applied over a dry or wet surface, except the wet-on-wet wash, which by definition is applied over a wet surface.

Flat Wash

This wash is used to create an even layer of color with no visible brushstrokes. Sounds easy, right? Well, actually this technique can be quite challenging! It takes time and practice to master it.

TIP
Mix more paint than you think you will need, because you don't want to run out before finishing your wash.

1 Create a large puddle of watery paint. Cut out a piece of 6" x 7" (15 x 18cm) paper. Using painter's tape, adhere the paper to a board and slant it about 45 degrees or less. This allows gravity to keep your paint bead line (leading edge) at the base of your stroke.

2 Load a size 12 round brush and pull it evenly across the top of the paper. You should see a long bead line at the base of the stroke. If it starts to drip down the paper, you have too much water. Tilt it back and soak up some moisture with a thirsty brush.

3 Load your brush again and start bringing the paint down without pressing too hard. Try to keep the bead line even, so you have even coverage.

4 Once you have reached the bottom, make sure you soak up any excess moisture or you will end up with a backrun or bloom (see page 53).

5 If you want to darken the value of your color, you can repeat the whole process but only after your first layer has completely dried.

6 Once your wash has dried completely, remove the painter's tape carefully and at an angle so you don't tear your paper.

Try using the flat wash technique to paint some irregular shapes like this one.

Gradated (or Gradient) Wash

This wash moves seamlessly from one value to another. It usually begins with a dark value, and as you move down the paper, it gets lighter. This is a great technique for painting skies. The difference with the flat wash is that you dilute your paint mix with water as you move downward, so begin with a more concentrated mixture of paint.

If you complete your gradient and the transition doesn't look as smooth as you'd like, load your brush with the concentrated mixture and work all the way down to the lightest part, trying to blend the paint already on the paper with horizontal strokes. If still needed, and before the paper dries, turn the painting upside down and begin with clear water, working all the way to the darkest value.

1 Repeat Steps 1 to 3 from the previous Flat Wash exercise.

2 Once you have reached about one quarter of your page, add clean water to your mixture to make it lighter. Load your brush with this diluted mixture and continue to paint, making sure to keep an even coverage of paint.

3 Continue to add water to your paint mixture as needed to create the lighter values of your gradient. You can use clean water for the final brush strokes. Once you have reached the bottom, make sure you soak up any excess moisture to avoid backruns.

4 Once your gradated wash has dried completely, peel the tape carefully and at an angle.

Variegated Wash (or Blending)

This is a wash in which you seamlessly incorporate or blend one color into another. This wash can be done in two ways. You can try to blend the two colors directly on the paper while they're wet, or you can paint one color at a time using the gradated wash technique. The latter is my preferred method.

1 Repeat Steps 1 to 3 from the Gradated Wash exercise. Allow it to dry completely and then turn the paper upside down.

TIP

The best colors to blend are those that are close to each other on the color wheel.

3 Once you have reached about three quarters of your painting, start using mostly clean water and paint gently so you don't disturb the color underneath.

2 Start at the top and use the same method as the gradated wash, using a second color. When you reach the middle section the two colors will begin to visually mix, creating a third color, orange.

4 Once your variegated wash has dried completely, peel the tape carefully and at an angle.

Wet-on-Wet Wash

This wash is a favorite among watercolor artists because of its playful nature. Wet paint is applied onto wet paper, allowing colors to mingle on their own. This technique creates some spontaneous blends and random effects. This technique is great for creating soft backgrounds and soft edges.

The amount of spreading will depend greatly on the level of moisture already on the paper, so learning to recognize paper wetness is key. If your paper is a puddle or glossy, the paint will spread wildly. If it has a more satin finish your paint will not spread as much.

I can't tell you how important it is to spend time learning about how water, paper, and pigments behave and interact in different situations. Wet on wet is considered to be one of the hardest techniques to control, and it's true; however, it is possible to learn to recognize certain key aspects that can help you achieve your desired effects.

1 Cut out an 6" x 8" (15 x 20cm) watercolor paper and tape it to a board using painter's tape. Using painter's tape or masking tape, divide the paper into three equal sections. Wet the first section with clean water.

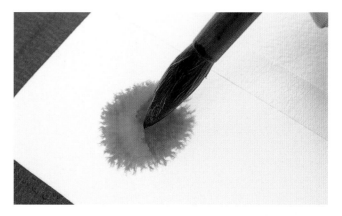

2 Use plenty of water so you have a glossy moisture level. Using mostly the tip of the brush, drop in some color and see it spread wildly.

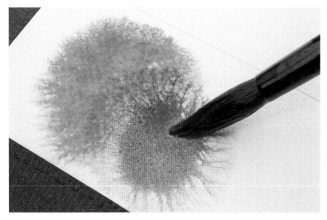

3 Rinse your brush and load with a different color. Drop this second color next to the first color and see how colors mingle and create all kinds of random effects.

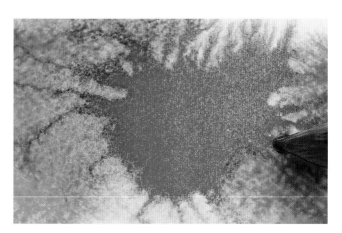

4 Drop in some more color and see what happens. I'm sticking to using two colors here, but you can drop in more.

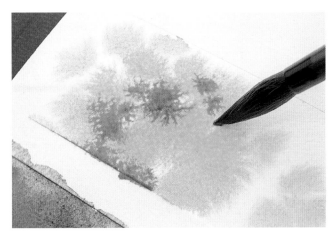

5 For the second section, try a slightly different effect by using less water (satin moisture level). Notice how there is less spreading.

6 For the last section, use even less water (matte moisture level). It will spread the least. If you like, add a few drops of clean water to create some blooms (see page 53).

7 Once your wet-on-wet washes have dried completely, peel the tape carefully and at an angle.

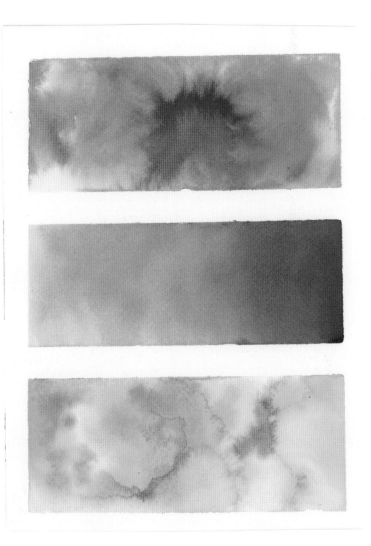

TIP

Different pigments behave and interact differently with other colors. Some push water more dynamically than others, so get to know your paints!

More Fun Techniques

We've gotten to know some of the basic and most well-known watercolor techniques, but our journey doesn't have to come to an end. There are so many more techniques to explore! In this section, we will learn some of my favorites. I know they will soon become some of your favorites, too!

Glazing (or Layering)

Glazing is a wet-on-dry technique in which a layer of wet color is applied over dry paint. Glazing allows us to visually mix colors through one of watercolor's most unique characteristics—transparency! The more glazes you add, the darker the value will become. It's extremely important to let each layer dry and paint each successive layer gently, so you don't disturb the layers underneath.

1 Using a size 8 round brush, paint a yellow circle. Allow it to dry completely.

2 Paint a second circle with permanent rose, partly overlapping the first. Allow it to dry. You now have a third color (orange).

3 Paint a third circle with blue overlapping the first and second circles. You now have two new colors: green and purple.

Charging Color

You can use this technique to add dimension to your paintings by adding a darker value of color where the shadow of an object might be. Begin by painting a shape with a thin layer of color. While this layer is still wet, load your brush with paint that has a slightly thicker consistency than the one you just laid down. Touch one edge of your shape with the tip of your brush to "charge" the new color into the lighter one.

Lifting Color

There are a few ways to lift, or remove, color. The first way is to lift paint with a clean damp brush while the paint is still wet. Use a bold stroke; otherwise the paint will just fill the area again. Another way to do this is with tissue paper. This is a great way to create clouds. The third way is to lift paint once it has already dried. This is done

mostly to correct or improve something. You can do this by using a clean damp brush, preferably an inexpensive, stiff one. Using circular motions, gently scrub the paint and blot out with a tissue. Be careful not to damage the surface. Remember that some colors will be more liftable than others due to their staining capacity.

TIP
Charging and lifting can be used together to help create the illusion of dimension. You can charge color to add "shadows" and lift color to create "highlights."

Masking

A mask is a way to protect your paper while you paint, enabling you to preserve the white of the paper. You can then leave the area white or paint it with a different color.

For masking, use a drawing gum, which is also known as liquid frisket. Apply it with an old brush, certainly not with an expensive one, as the bristles will get ruined. You can also buy a tool that is made for this purpose.

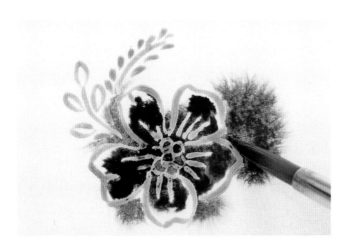

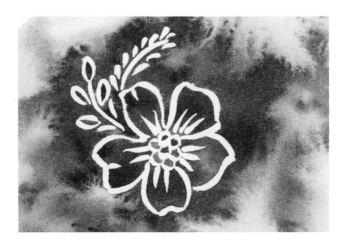

1 Apply the frisket and allow it to dry completely. Tip: To help protect the bristles of your brush, dip it into a soapy water solution before applying masking fluid.

2 Once your paint is completely dry, remove the mask by peeling it off with your fingers or using a masking fluid pick-up made especially for removing dried masking fluid from your paper.

Negative Painting

This is a fascinating technique in which you paint a darker background around a lighter object to define it. With each successive layer you create more depth and dimension. Your final layer should be the darkest color. This is a wet-on-dry technique, so you need to allow each background layer to dry completely before adding a new one.

1 Using the wash technique of your choice, paint a light-colored background. Let it dry.

2 With a darker color, paint hard edges around the object you wish to outline. Soften the color with water as you move away. Allow the paint to dry.

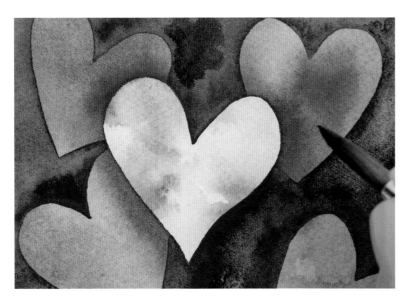

3 Allow the paint to dry. Repeat Step 2 to paint around other objects you wish to outline. Notice how each layer gets darker and darker.

Creating Visual Texture

There are many techniques that can help us create visual texture. One of the easiest ways to do this is by using granulating paints (see page 21). You can increase the granulating effect by using rough watercolor paper and a lot of water. If you don't have granulating paints, or you just want to explore other ways to create visual texture, give one of the following a try!

Blooms

When water is dropped on a layer of color that is still damp, the water will push the pigment, creating a backrun, or water bloom. Many artists try to avoid creating blooms, but I personally love the organic, spontaneous look it creates.

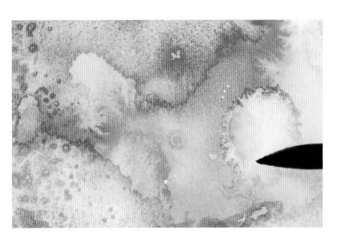

Blooms create exciting, unpredictable effects.

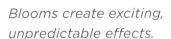

Salt Texture

Another technique used to create visual texture is to add salt when the paint is still damp. I like using coarse kosher salt, but you can try different types of salt. For this technique, timing is important. If you add the salt too soon, when the paper is still too wet, the effect will not be as visible. Add the salt just after the paper has lost some of its sheen. Different types of salt and different pigments will give you different results. Let the paint dry before removing the salt with your finger or a small spatula.

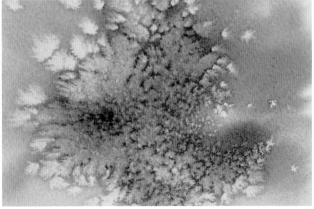

Using salt is one of the most fun ways to add gorgeous texture.

Spattering

This technique creates a loose and expressive look and is perfect for painting a starry sky. Load a toothbrush or other sturdy brush with either water or paint, then flick the bristles with your finger or tap the handle with another brush to control the direction of the spatter.

In this example, I'm using white gouache to create the stars in a blue sky.

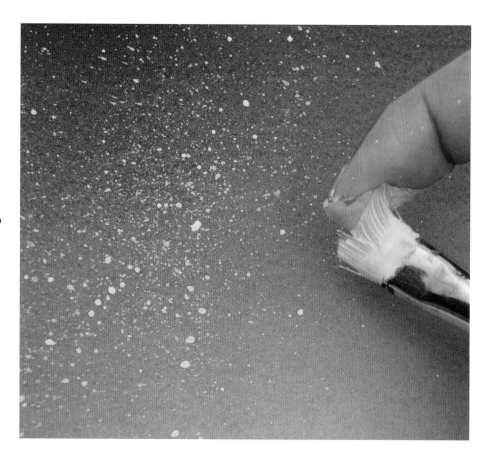

Dry Brush

This technique will give you a unique painterly effect. The more texture your paper has, the more you will be able to see this effect. With a relatively dry brush, pick up paint and create a quick bold stroke on your dry paper and leave it.

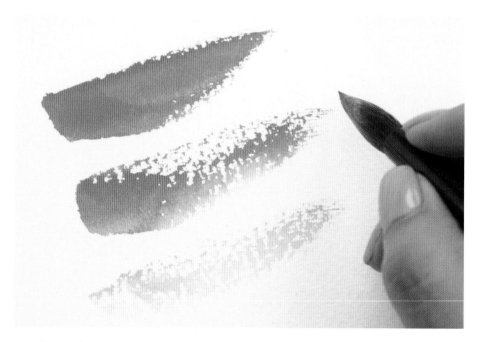

Each stroke here shows how much water was on the brush. The less water (bottom stroke), the more visible the effect.

Scumbling

This is a wet-on-dry technique that is used to create rich texture. This is a great way to paint loose foliage, or as shown here, an abstract center for a flower.

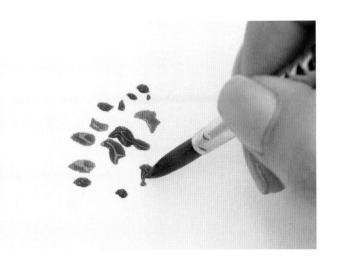

1 Load a round brush with paint, then dab with the tip of your brush to create loose dots.

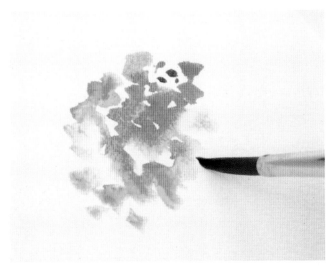

2 Soften some of the edges with clean water to create softer values.

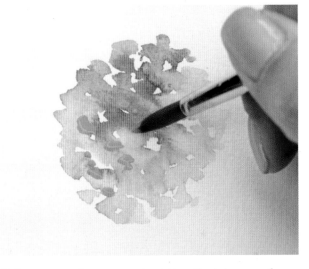

3 Once you have created the first layer of scumbling, allow it to dry completely before creating a new one.

4 Repeat Step 2 to soften the dots, then repeat Steps 1 and 2 with more colors if desired.

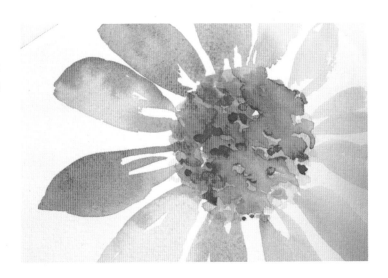

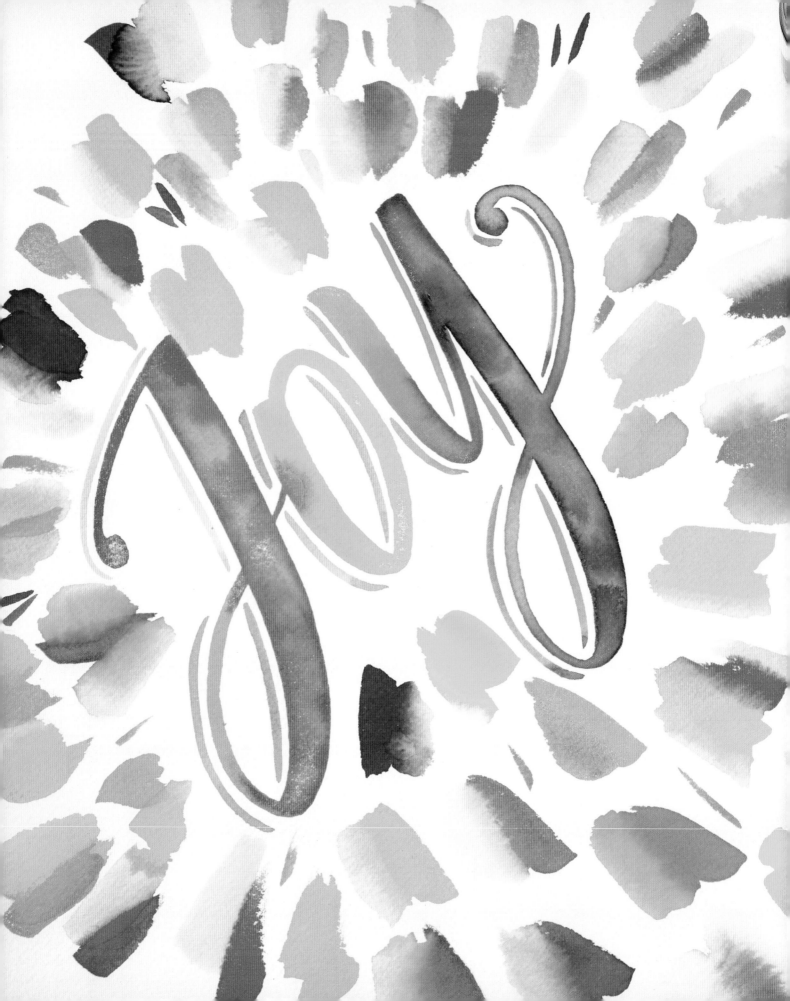

Brush Lettering Basics

Lettering by hand has exploded in popularity in the last few years. Lettering combines beautifully with watercolor and is actually how I got started painting with watercolors. This chapter looks at different types of lettering, and then shows you how to get started with brush lettering—a form of modern calligraphy that uses brushes and brush pens to create gorgeous lettered artwork.

Types of Lettering

Through letters, I've found a way to create and to promote things that inspire me and others. You can do this through different disciplines that may seem similar. It's important to know their differences so you're free to choose what interests you!

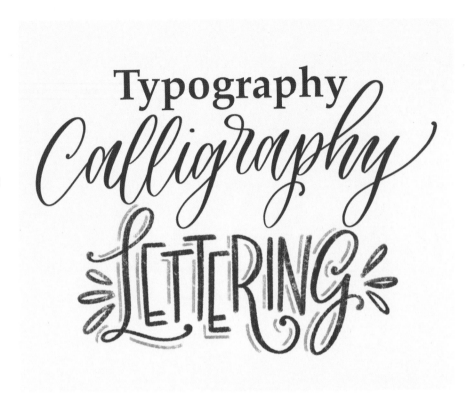

Typography

Typography is the art of arranging type to make written language easy to read and appealing when displayed. A typeface is a collection of pre-made typographical symbols and characters. They're the letters and other characters that let us put words on paper (or screen). It's quite common for people to refer to lettering as typography, but in reality typography is a subset of lettering.

Calligraphy

The Greek word *calligraphy* translates to "beautiful writing." It is a type of decorative writing produced with a pen or brush that is based on penmanship. With the early use of reeds and brushes dipped in ink, calligraphy quickly developed into an early art form. Ancient scribes used papyrus, clay tablets, old pieces of pottery, or flakes of limestone to write on, and they aimed to make their writing very special.

Fast-forward several centuries later and calligraphy is thriving. Calligraphers now use pens with nibs to create these beautiful letters.

TRADITIONAL CALLIGRAPHY

Traditional calligraphy reproduces different ancient styles of writing such as Copperplate and Spencerian. This calligraphy style follows a particular technique, including posture of the hand, angle of the pen, varying pressure to create thick downstrokes and thin upstrokes, as well as particular strokes and letter formations. Traditional scripts are created with specific tools and precise measurements.

Modern Calligraphy

MODERN CALLIGRAPHY

Modern calligraphy style is a fresh, new approach that encourages creativity and allows you to break some of the formal rules of traditional calligraphy while using traditional and nontraditional calligraphy tools. It is more of a gestural style of writing that expresses emotions and feelings through beautifully well-formed lines.

FAUX CALLIGRAPHY

Within modern calligraphy you'll hear references to faux (or fake) calligraphy. This style allows you to take a regular pen like a ball-point pen or fine-point marker and manually make or draw the thicker downstrokes you would achieve with varying pressure when using a flexible nib or brush pen.

Hand Lettering

Lettering is the art of illustrating letters, just like you would illustrate a flower, a tree, or a bird. Lettering is used to create custom graphics such as posters, signs, and chalkboard art. These custom letterforms are usually created for a single use. Lettering can be done digitally or by hand.

Before the digital era, handpainted lettering was the only way to put text on a building or a billboard, but now businesses are rediscovering the unique beauty of handmade, opening up many exciting opportunities for talented lettering artists!

Brush Lettering in the Modern Calligraphy Style

What? Lettering AND calligraphy? Why yes, please! Brush lettering brings together these two beautiful crafts, and it can be done with either brush pens, markers, or even actual brushes for watercolor lettering—my favorite method! Because of the appearance of the letters, it can be described as lettering in the modern calligraphy style. With each letter, heavy pressure is applied on the downward stroke and light pressure is applied on the upward stroke. To succeed at brush lettering, it is important to familiarize yourself with the tools and techniques needed to create these letterforms.

Brush Lettering Tools

Since brush lettering has become wildly popular, the number of pens and other tools available has exploded. Here I'll go over some of the basic types. The best way to learn about the different tools is to try them out and choose the ones that work best for you.

Brush Pens and Markers

Brush pens have a flexible felt nib that allows you to create nice thick and thin lines. Brush pens come in different sizes (thicknesses) that lend themselves to different size letters. The tips also vary from more firm to more flexible (softer). A very flexible tip can be harder to control, so I recommend a firmer tip for beginners.

The most common color of brush pen is black, but some brands come in a wide range of fun colors.

Markers are usually available in a variety of colors. They work well for larger letters. The prices vary, but even the most inexpensive ones can be used to create bold lettering.

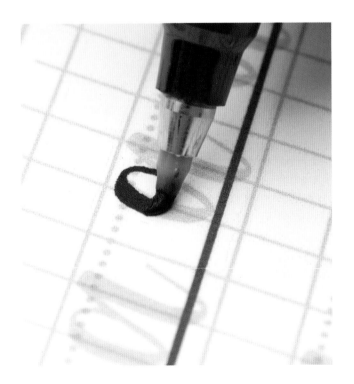

Brushes

Of course you can also use brushes for brush lettering. I mostly use brushes in my lettering so I can use any color watercolor I like.

ROUND WATERCOLOR BRUSHES

Synthetic brushes spring back to a point, giving you great brush control. My favorite sizes are 2 and 3.

LINER BRUSHES

You can create very fine letters with liner brushes, but I mostly recommend them for experienced lettering artists as they require more control. My favorite sizes are 3 and 6.

WATER BRUSHES

Water brushes have a reservoir that holds water, so you don't need a separate water container. Be sure to buy a decent-quality water brush, as some may leak.

Paper

For brush pens and markers, you can definitely use regular printing paper. However, I recommend using specialty paper that allows brush pens and markers to glide with more ease. This can help extend the life of your pens by preventing fraying.

FOR BRUSH LETTERING

For brush lettering, I often use tracing paper, marker paper, and laser printing paper.

FOR WATERCOLOR LETTERING

When using watercolors, I highly recommend using paper made specifically for water media and no less than 140 lb.

Watercolor

For watercolor lettering, I recommend using liquid watercolors. They come in many different colors and are ready for you to use. You can also use regular watercolors previously mixed with water to a level 1 consistency (see page 32). Use a palette with wells, or if you prefer, purchase small paint pots with lids, perfect for storing your paints. I have also used food coloring diluted with water for lettering! Note that liquid watercolors are not lightfast, which means colors can fade over time. Also, the

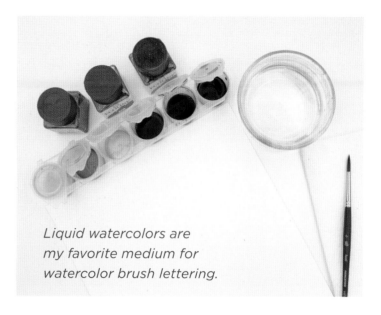

Liquid watercolors are my favorite medium for watercolor brush lettering.

pigment is dye based, which means it binds directly with the fibers of your paper and will stain the paper—and your hands!

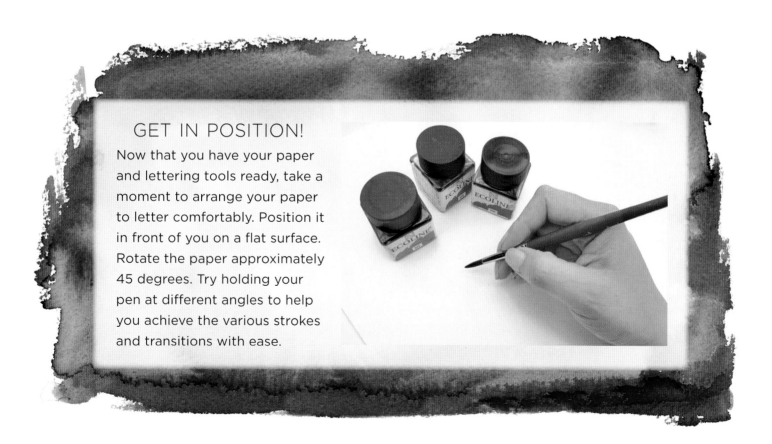

GET IN POSITION!

Now that you have your paper and lettering tools ready, take a moment to arrange your paper to letter comfortably. Position it in front of you on a flat surface. Rotate the paper approximately 45 degrees. Try holding your pen at different angles to help you achieve the various strokes and transitions with ease.

Terminology

Drawing letters that are uniform and readable is key. You can create handlettered pieces that are beautiful, but if your audience can't read the letters, then they haven't accomplished their full purpose. In this section, I walk you through some basic terminology that will help you create letters that are a pleasure to look at *and* easy to read.

Guidelines

Guidelines are where your letters live: a comfortable and happy place that provides the framework for creating beautiful, polished letters. Let's talk about what each line means:

Cap line: Height of the capital letters.

Waist line: This line is above the baseline (shown as a dotted line).

Baseline: This is the boldest line. It's a very important line where all of our letters "sit." You always return to this line to find your way.

Descender line: This is the line that all your descending letters will touch.

Ascender line: All of your ascending letters will reach for this line.

Slant lines: The slant lines are a guide that can help you make more uniform, polished letters. Since you are writing at approximately the same angle, you will create lettering pieces that are pleasing to the eye and easier to read. This is especially helpful when you are creating a longer quote or phrase.

X height: The space between the baseline and waistline. If you look across a line of writing you will read between the waist and base line. The height of lowercase letters is based on the height of the lowercase letter "x." This does not include ascenders or descenders.

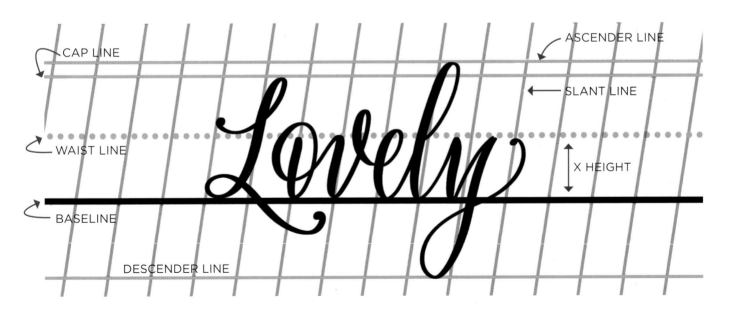

Strokes

Repeat after me: "Thin up, thick down." In order to create letters in the modern calligraphy style, upstrokes must be thin, and downstrokes must be thick.

Thin Upstrokes

Thin upstrokes do not necessarily have to be hairline-thin. You can begin by allowing them to be thicker if that means they will be less shaky. As long as there is a good contrast between your thin upstrokes and your thick downstrokes, you will be okay! Practice will help you gain the control you need to create lines that are consistent and thin at the same time.

Thick Downstrokes

Beautiful thick downstrokes are those that are consistently the same width. It's also important these have the same slant since it is the most prominent stroke in your letters.

Eight Basic Strokes

Below are the building blocks of your letters. Practice them to gain control of your brush.

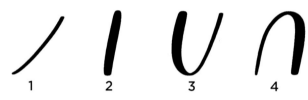 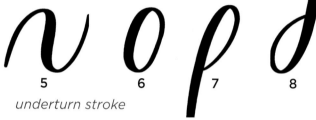

1 Entrance stroke: *Thin upstroke*

2 Full Pressure stroke: *Thick downstroke*

3 Underturn stroke: *Thick downstroke to thin upstroke*

4 Overturn stroke: *Thin upstroke to thick downstroke*

5 Compound curve: *Overturn stroke plus underturn stroke*

6 Oval: *Thin upstroke counterclockwise to thick downstroke that connects to upstroke*

7 Ascending stem loop: *Thin stroke counterclockwise to thick downstroke*

8 Descending stem loop: *Thick downstroke to thin upstroke*

Forming Letters

It's important to recognize the main difference between cursive writing and brush lettering.

For cursive writing, you don't lift your pen until you have finished your word. With brush lettering you do.

Sometimes even those basic strokes will be more difficult to achieve. It's okay! You can go back and touch up that stroke to make it look just right. When you're lettering with a brush, think of it as "painting" letters.

jelly je l l y

Look at the word "jelly." I've broken it down to all the strokes that went into making this word. Wherever you see a gap is where I lifted my brush pen.

Practice Alphabet

Place a sheet of tracing paper over these pages to practice the lowercase letters of the alphabet. Follow the direction of the arrows to create each letter. Practice each one until it feels natural.

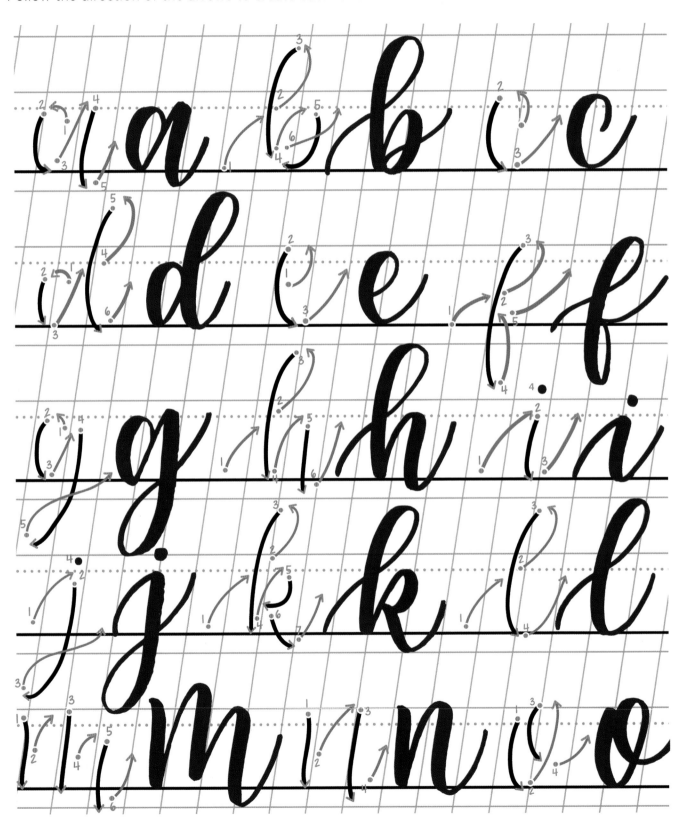

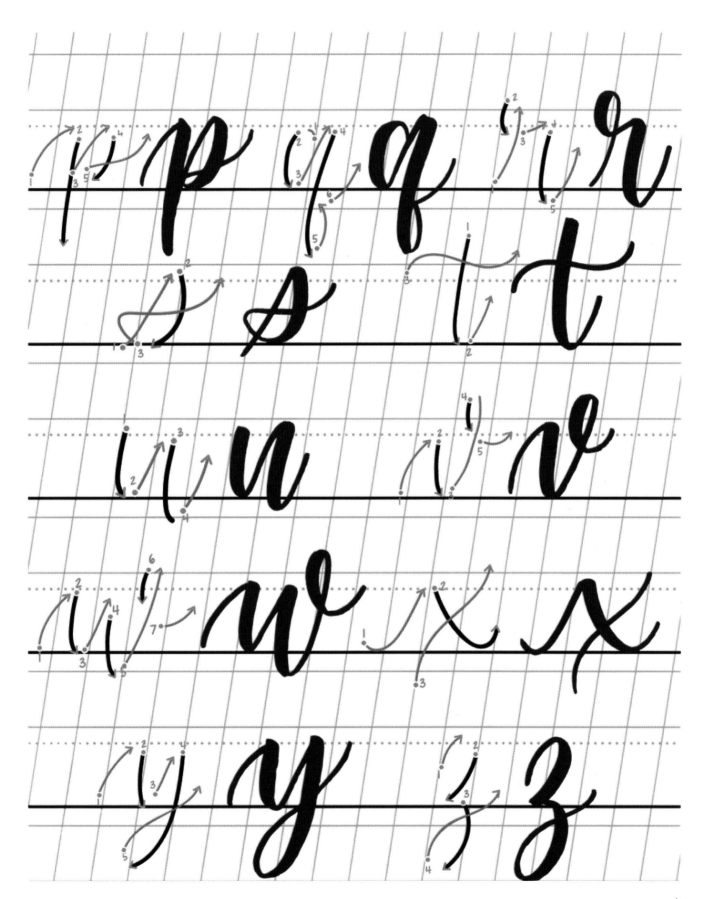

Drills

Before we begin lettering with a brush, let's loosen up with some drills. For the following examples, I will be using a size 6 round watercolor brush.

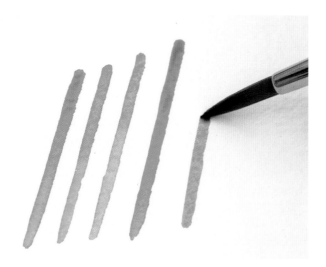

Thin upstrokes: Think of it as "pulling" your brush and using the very tip to create the thin upstrokes.

Thick downstrokes: "Push" your brush to create a uniform thick line. Notice how all these downstrokes have the same angle. This is important because the downstroke is the dominant stroke in your letters.

Overturn (above) and underturn are strokes we use often. The more you practice, the easier it will be to control the pressure you put on your brush and release from your brush to create the thick and thin strokes combined.

Underturn

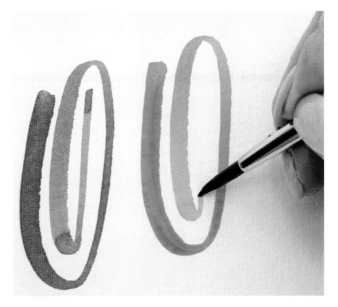

Another great way to loosen up and expand your range of motion, as well as work on your precision skills, is to do these two simple exercises. The first one I call a "slinky." It's like an underturn stroke that keeps going. Practice it in different sizes. The bigger, the better.

The other drill I like to use is called "logs." Here you're learning how to control the amount of pressure on your brush, transition, and then carefully paint between strokes. Your precision will grow immensely with these simple drills!

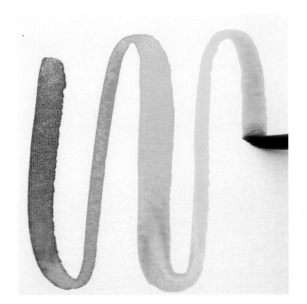

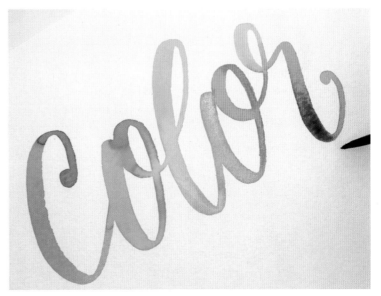

This stroke is the compound stroke, but we are adding a little color twist. Use this stroke to test the colors you want to use for your lettering. Here you will see if your colors work well together or if they need to be changed. I like to use colors in rainbow order for rainbow lettering!

Block Letters

Block letters are hand-drawn capital letters that aren't joined and don't have extended features called *serifs* at the end of each stroke. Combining block letters with letters in the modern calligraphy style is a great match!

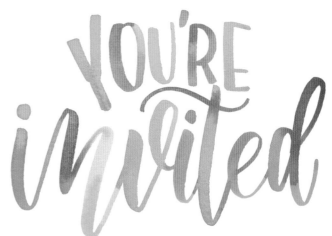

Block letters combine beautifully with modern calligraphy.

Simple block letters come alive with colorful watercolors.

Ombré Letters

Ombré is the French word for "shaded" and refers to color that is shaded, or graduated, in tone. For this example, I'm using a light violet color as a base, and then I add the same color except more concentrated.

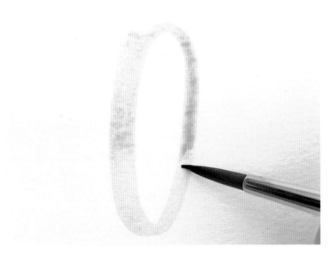

1 Start by painting your first letter. Using a thirsty brush, soak up some of the water from the bottom third of the letter. The top should still be wet.

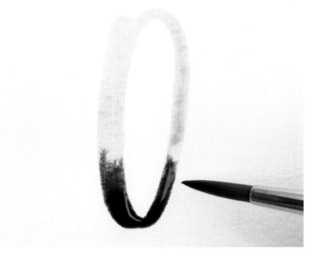

2 Drop in more concentrated color, and then, using a clean damp brush, smooth out and blend the transition from dark to light.

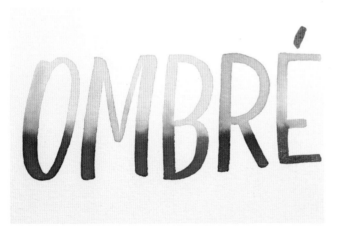

3 Once you like how the transition looks, soak up any extra paint at the bottom of your letters.

You can do something similar with two colors. Begin by lettering with a very light version of the lightest color. Once the letter has lost some of its sheen, drop one color on the upper half and another color toward the bottom. Blend slightly with a clean, damp brush.

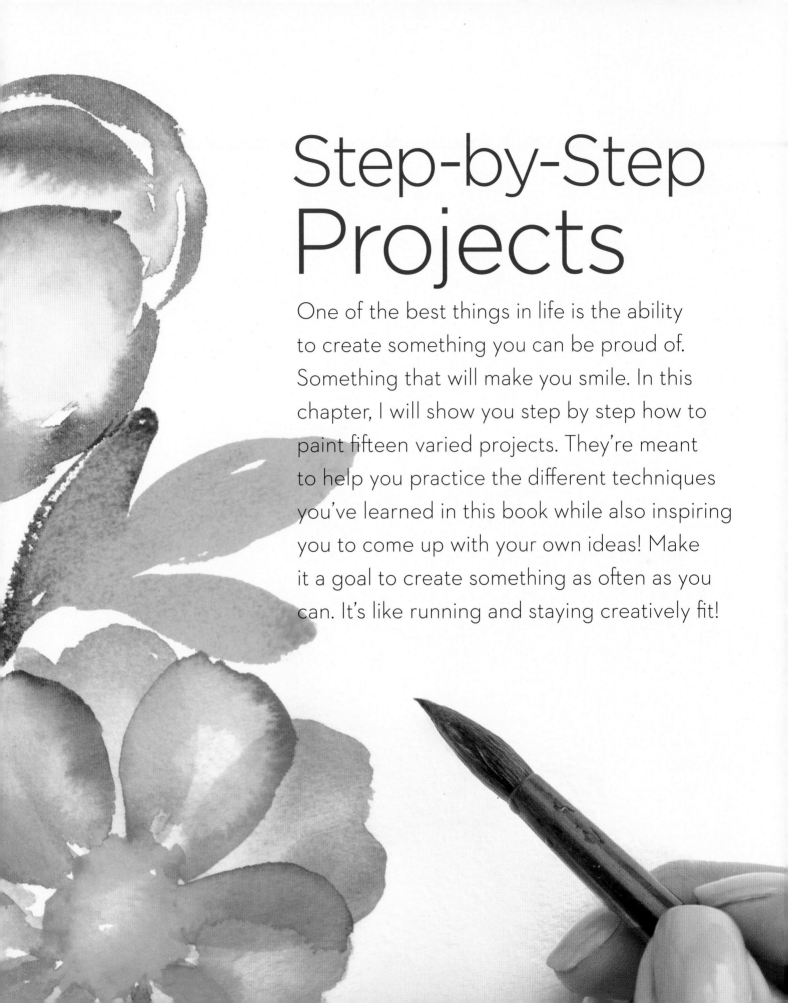

Step-by-Step Projects

One of the best things in life is the ability to create something you can be proud of. Something that will make you smile. In this chapter, I will show you step by step how to paint fifteen varied projects. They're meant to help you practice the different techniques you've learned in this book while also inspiring you to come up with your own ideas! Make it a goal to create something as often as you can. It's like running and staying creatively fit!

Sparkling Shards

BRUSHES

Size 2 round synthetic

Size 8 round synthetic

Size 12 round

TECHNIQUES

Wet-on-wet wash (page 48)

Blooms (page 53)

Lifting color (page 51)

Scumbling (page 55)

One of my favorite things about watercolor is its translucent nature. Through glazing we can "stack" layer upon layer of color to create a stained glass effect. Although I've never tried my hand at this beautiful art, I can certainly paint something that reflects its delicate beauty and transparency.

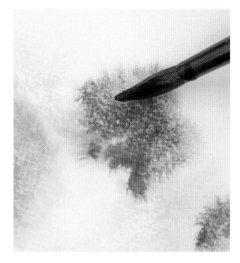

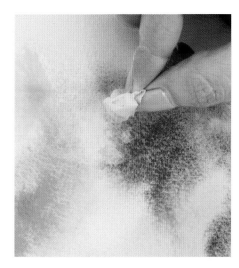

OTHER SUPPLIES

9" x 12" (22.9 x 30.5cm) watercolor paper

Tissue paper

Stiff brush or old toothbrush (optional)

COLOR PALETTE

1 With clean water and the size 12 brush, wet the paper. Using the wet-on-wet technique, drop paint randomly on your paper. Start with cobalt turquoise, then violet next to it. Once the paper has lost some of its sheen, drop in clear water to create blooms.

2 Use tissue paper to lift some paint and create more texture. Allow everything to dry completely.

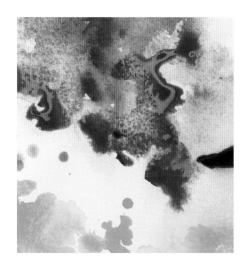

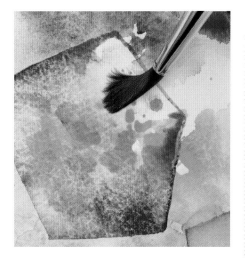

3 Using the scumbling technique, apply wet paint in some areas, leaving hard and soft edges. You can soften the edges with clean water or lift paint with tissue paper. You can also use a loaded brush to throw in big paint drops. Let dry.

4 With the size 8 brush, draw a polygon. Use violet to create the edges and quickly blend with water. Paint several more using other colors and making sure not to overlap. They don't have to have the same number of sides but should be around the same size.

A. Viridian

B. Cobalt turquoise

C. Sap green

D. Violet

E. Bright violet clear

F. Marine blue

G. Gold gouache

5 Once your polygons are dry, use the size 2 brush and bright violet clear to paint a line on the bottom and left side of each polygon. Then with a clean, damp size 8 brush, soften the lines to look like shadows. Let dry.

6 Repeat Steps 4 and 5 to paint more clear polygons over the first round. These can be medium and smaller in size, and in different colors, such as marine blue.

7 Once your glass shards have dried, add some additional splatters and let them dry. Mix gold gouache with a little water. Use the size 8 brush to apply it to some of the glass shards, avoiding the shadows.

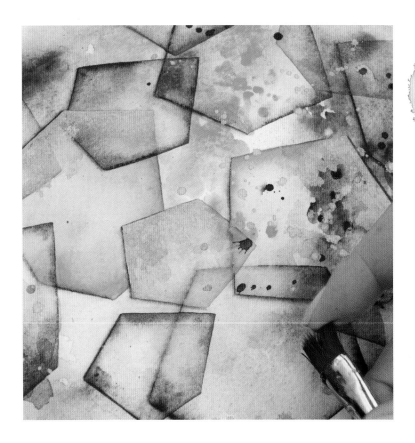

TIP
If you didn't have enough time to soften an edge before it dried, try charging color to it to help blend it with the rest of your shape.

8 Take a moment to evaluate your painting. If you would like more texture, add more paint spatters or paint drops with a toothbrush or a small stiff brush for more control.

Origami Bunny

This fun project was inspired by my daughter's love for origami—the Japanese art of paper folding. Because it's made up of simplified geometrical shapes with many straight sides and sharp corners, it's the perfect practice subject for beginner watercolorists.

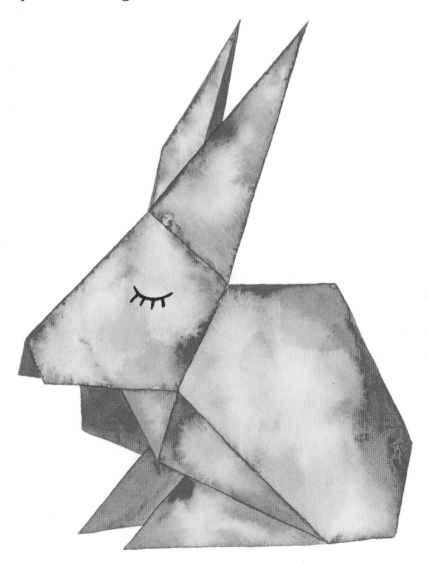

BRUSHES

Size 1 or 2 round synthetic

Size 6 round synthetic

Size 8 round synthetic

TECHNIQUES

Flat wash (page 44)

Blooms (page 53)

Wet-on-wet wash (page 48)

Lifting color (page 51)

OTHER SUPPLIES

9" x 12" (22.9 x 30.5cm) watercolor paper

Bunny template (page 132)

Mechanical pencil with HB lead

Kneaded eraser

Lightpad (optional)

Heat tool (optional)

COLOR PALETTE

A. Pyrrol scarlet

B. Yellow deep

C. Indigo

A B C

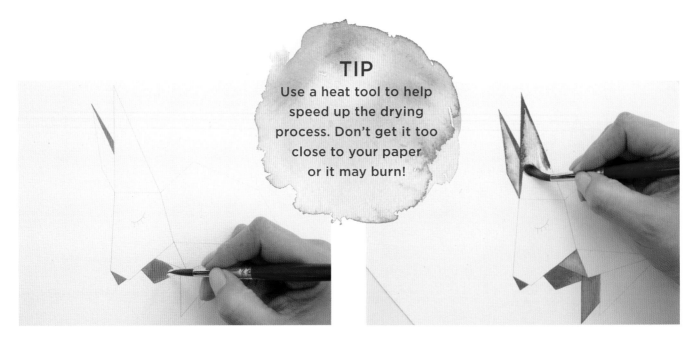

TIP
Use a heat tool to help speed up the drying process. Don't get it too close to your paper or it may burn!

1 Trace the bunny template. Mix a puddle of pyrrol scarlet with a level 2 consistency (see page 32). With a size 6 brush and using the flat-wash technique, paint the first three small shapes. Let dry.

2 Let's paint the inner ears of the bunny. Paint the outline of one or two sides of one ear. Quickly rinse your brush and blot well. Use the clean, damp brush to pull color from the edges toward the center to create high contrast.

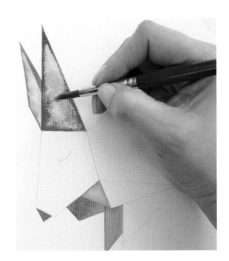

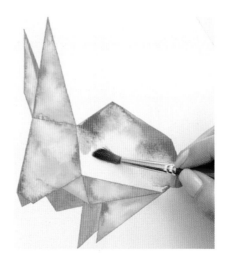

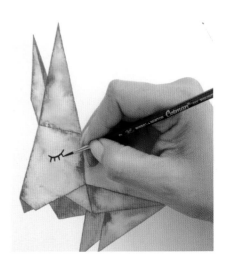

3 Using the wet-on-wet technique, pick up a little yellow deep and drop it in the middle of your wet shape. For additional texture, create a bloom by dropping in clean water. Let dry.

4 For the largest shapes, switch to a size 8 brush. Repeat Steps 2 and 3 and use mostly clean water to create high contrast. Finish with a wet-on-wet wash to add color and texture.

5 Once your bunny is completely dry, paint the eyes with indigo and a size 1 or 2 round brush.

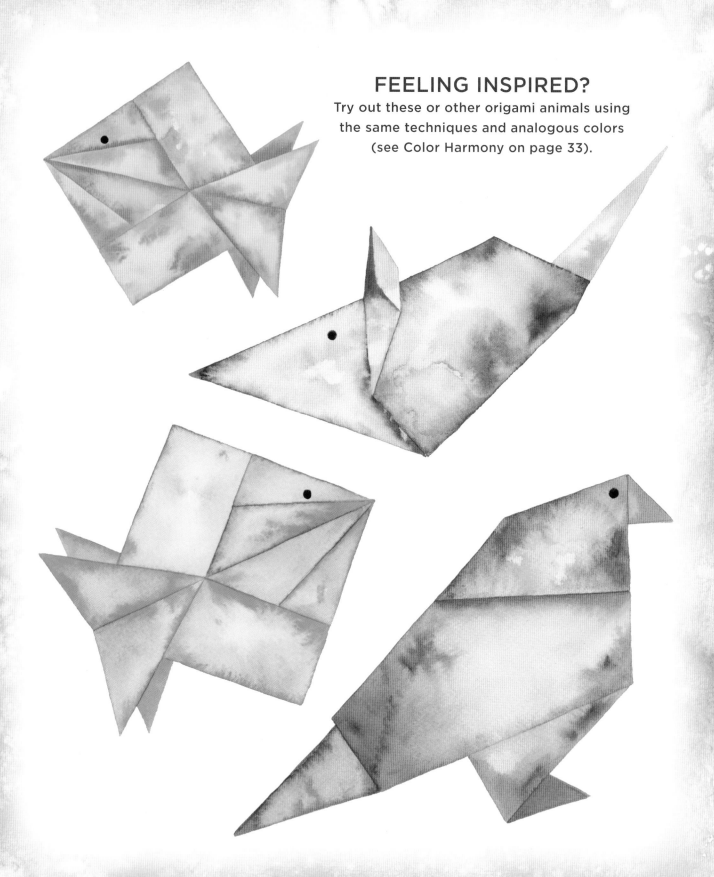

FEELING INSPIRED?

Try out these or other origami animals using
the same techniques and analogous colors
(see Color Harmony on page 33).

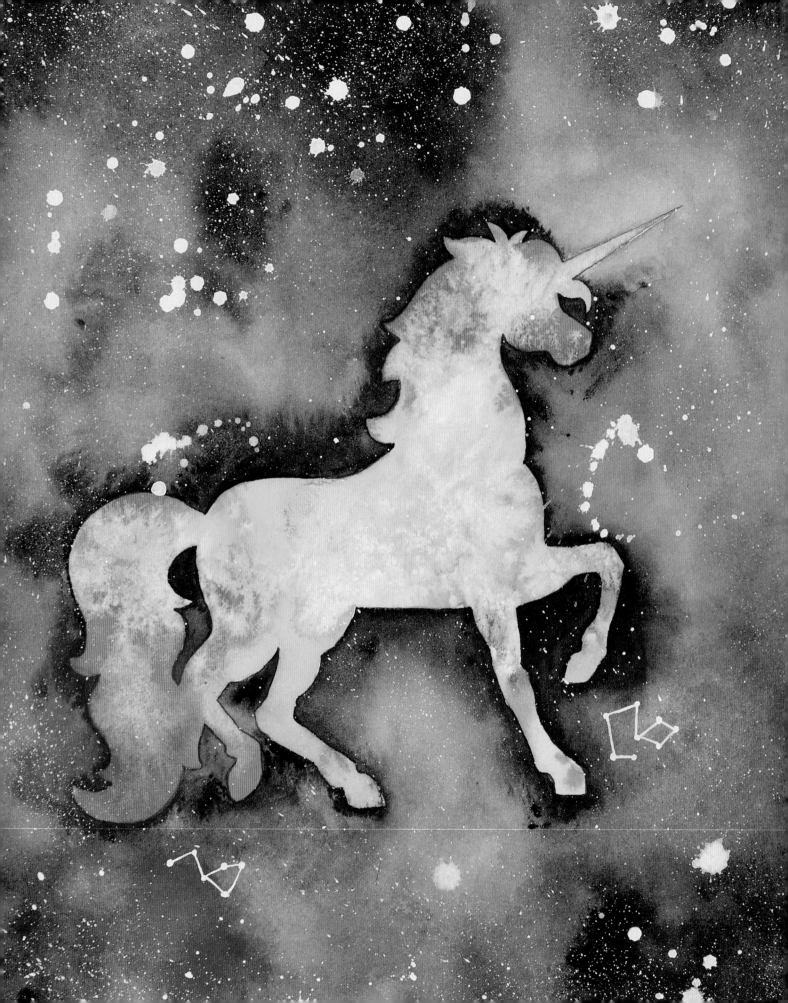

Galaxy Rainbow Unicorn

TIP

We will be using lots of water and creating lots of layers. I recommend attaching your paper to a drawing board with painter's tape to avoid warping.

This bold piece is an explosion of color and visual textures. What could be more fun than painting a rainbow unicorn and a magical galaxy background with nebulas and constellations? This project is truly candy for your eyes!

BRUSHES

Size 2 round

Size 6 round

Size 14 round

Size 10/0 liner brush

TECHNIQUES

Salt texture (page 53)

Wet-on-wet wash (page 48)

Negative painting (page 52)

Lifting color (page 51)

Glazing (page 50)

Spattering (page 54)

OTHER SUPPLIES

10" x 14" (26 x 36cm) watercolor paper

Unicorn template (page 132)

Mechanical pencil with HB lead

Kneaded eraser

Lightpad (optional)

Sturdy surface

Painter's tape

Coarse salt

Tissue paper

Old toothbrush

White gouache

COLOR PALETTE

A. Indigo • B. Cerulean blue

C. Compose blue • D. Marine blue

E. Bright violet clear • F. Bright opera

G. Yellow-orange • H. Yellow deep

I. Lemon yellow • J. Sap green

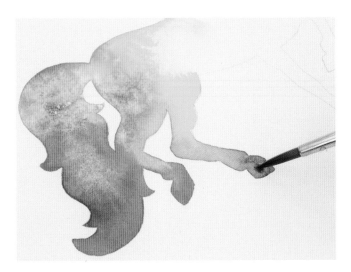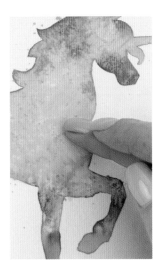

1 Use the template to trace the unicorn's silhouette. Using a size 6 round brush and level 2 consistency (see page 32), paint a small area of the tail with bright opera, then drop in some bright violet clear. Continue with yellow-orange, the yellows, green, marine blue, and violet. Switch to a size 2 brush for the horn.

2 Before the paint dries, add coarse salt and drops of clean water here and there to create some gorgeous textures! Let it dry.

3 With your fingers, gently remove the salt.

TIP
When painting your background, use water to keep the edges moist at all times. If they dry, they will immediately create a hard edge.

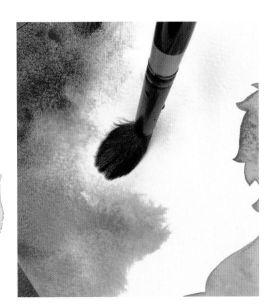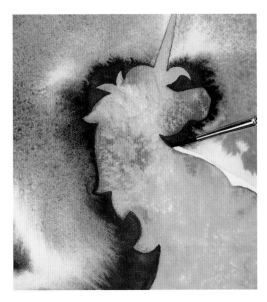

4 Using the size 14 brush, wet the top left section with clean water. With the wet-on-wet technique, paint the outer edges with the darker colors. Leave some areas bare and soften edges with clean water. Drop in some lighter colors. Paint the top right section.

5 Using the negative painting technique with indigo and the size 6 brush, begin painting around the unicorn and blend with the rest of your damp background. Use a size 2 brush to create sharp lines to define the unicorn silhouette and paint in smaller spaces.

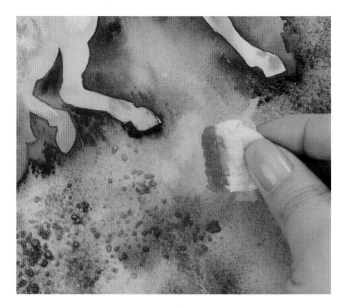

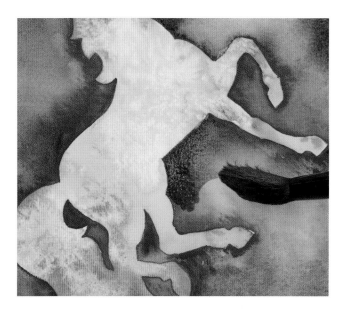

6 Repeat Steps 4 and 5 to paint the bottom sections of the painting. Use tissue paper to soften the edges and/or "lift" paint to create highlights. You can also sprinkle coarse salt to create texture. Let the painting dry completely.

7 Add intensity by glazing with a second and third layer of the same colors. You can also layer colors that work well together, for example, lemon yellow over a small section of compose blue. Repeat this glazing process a few more times and allow each layer to dry before painting a new one. Let dry.

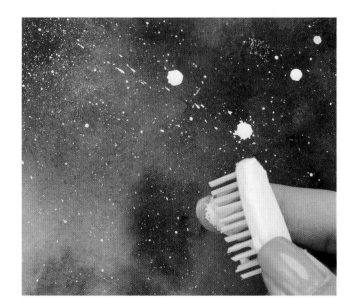

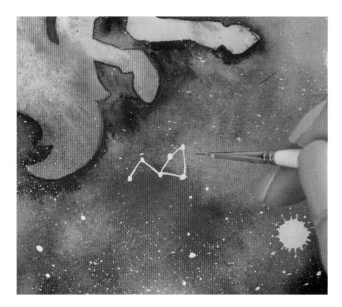

8 It's time to paint the billions of stars in the galaxy! Mix a small amount of white gouache with a little water. With an old toothbrush, pick up some and create tiny splatters using your index finger. Use a size 6 brush to create bigger drops and splatters.

9 Using the liner brush, paint in some constellations! You can research them to see how they actually look or, as I did, just imagine what they might look like!

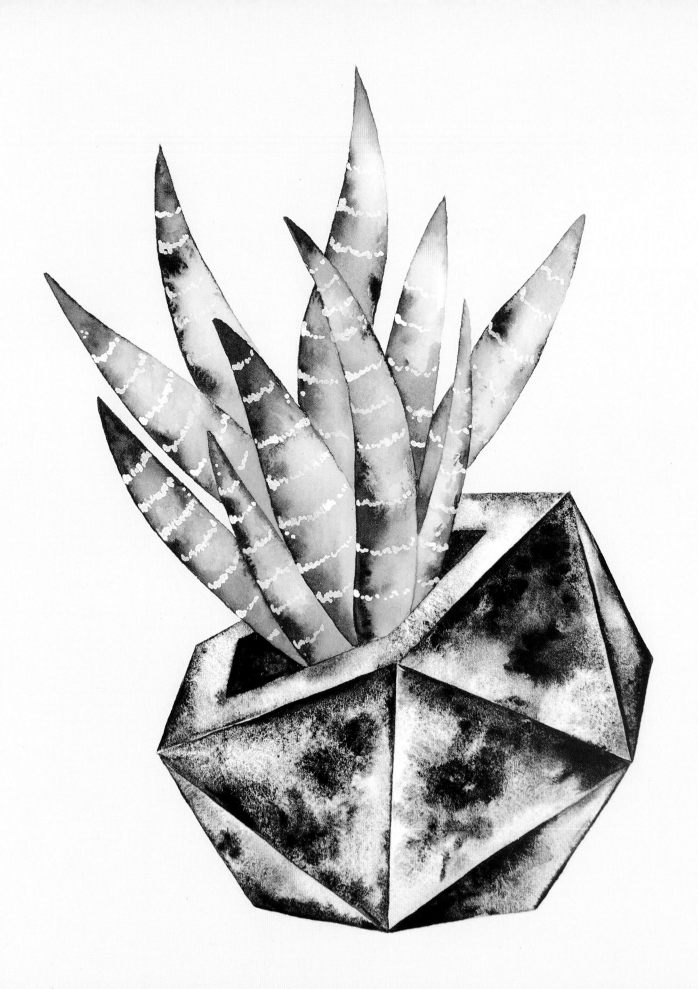

Zebra Succulent

I'm so inspired by photos of beautiful succulents and planters I see online, but I don't have a green thumb. If you're like me, you don't have to keep a real succulent. Just paint one! We will be using a very special granulating paint for the planter to mimic the look of concrete.

BRUSHES
Size 2 round synthetic
Size 8 round synthetic

TECHNIQUES
Flat wash (page 44)
Charging color (page 50)
Lifting color (page 51)
Wet-on-wet wash (page 48)

OTHER SUPPLIES
9" x 12" (22.9 x 30.5cm) watercolor paper
Succulent template (page 133)
Mechanical pencil with HB lead
Kneaded eraser
Lightpad (optional)
Paper towel
White gouache

COLOR PALETTE
A. Granulating black
B. Sap green
C. Deep sap green
D. Permanent rose

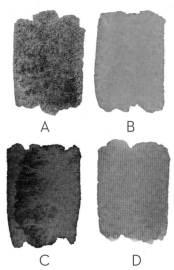

A B

C D

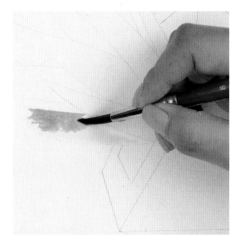

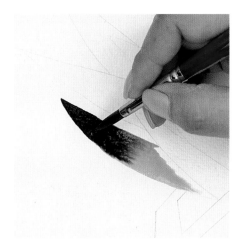

1 Trace the template. Using a size 8 round brush and a level 2 consistency (see page 32), mix a puddle of sap green paint. Begin painting a leaf with a flat wash.

2 Pick up some deep sap green and charge color, starting at the tip of the leaf. You can also charge color on the outer edges. Try using a satin moisture level (see page 38) for more control.

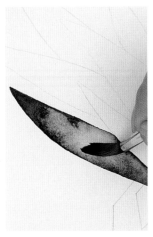

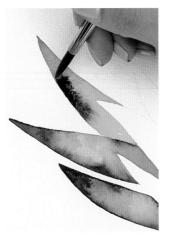

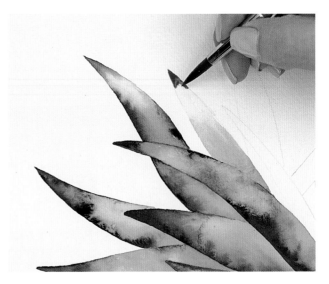

3 Rinse and blot your brush, then "lift" paint to create a highlight in the middle section of the leaf.

4 Repeat Steps 1 to 3 to paint a few more leaves.

TIP
If you use too much water, you will have less control over your paint spreading.

5 Now add some red-tipped leaves. Wet one leaf with clean water to a satin finish. Drop some sap green on the bottom portion. Rinse your brush, pick up a little permanent rose, and paint the tip. Leave space between the two colors so they don't mix and create "mud."

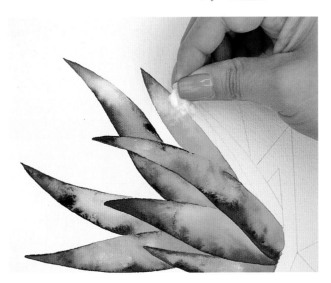

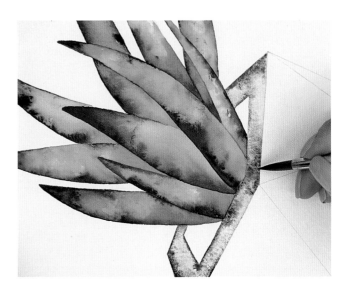

6 Use paper towel to blot excess moisture between the two colors. To add depth, charge a little deep sap green on the outer edges of your leaf. Finish painting the rest of your leaves and let dry.

7 Mix a level 2 consistency puddle of lunar black. Wet the upper rim of the planter with clean water (satin finish). Pick up some of the black and charge color all around the outer edges. The less paint you use, the more it will show the granulating effect. Let dry.

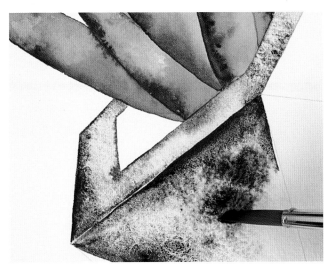

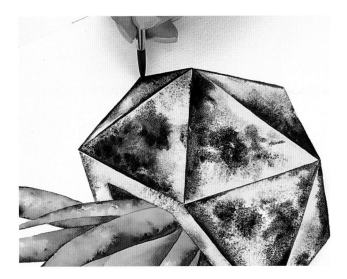

8 Paint the rest of the planter. Use a glossy moisture level for the larger sections and satin for the smaller ones. Wet one section at a time, charge color all around the outer edges, and use the wet-on-wet technique to create random effects. Let dry.

9 Using the flat-wash technique and black, paint the inside of the planter. Take a moment to evaluate the painting and touch up any corners that may need to be sharpened. Allow everything to dry completely.

TIP
Use only a small amount of white paint. A little goes a long way!

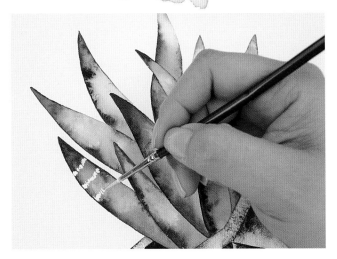

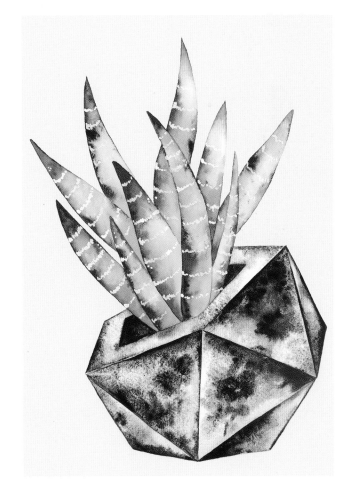

10 Mix a little white gouache with some water—just enough to be able to apply with a brush. Using a size 2 brush, create the stripes on each leaf. Make sure to space them out and allow them to dry.

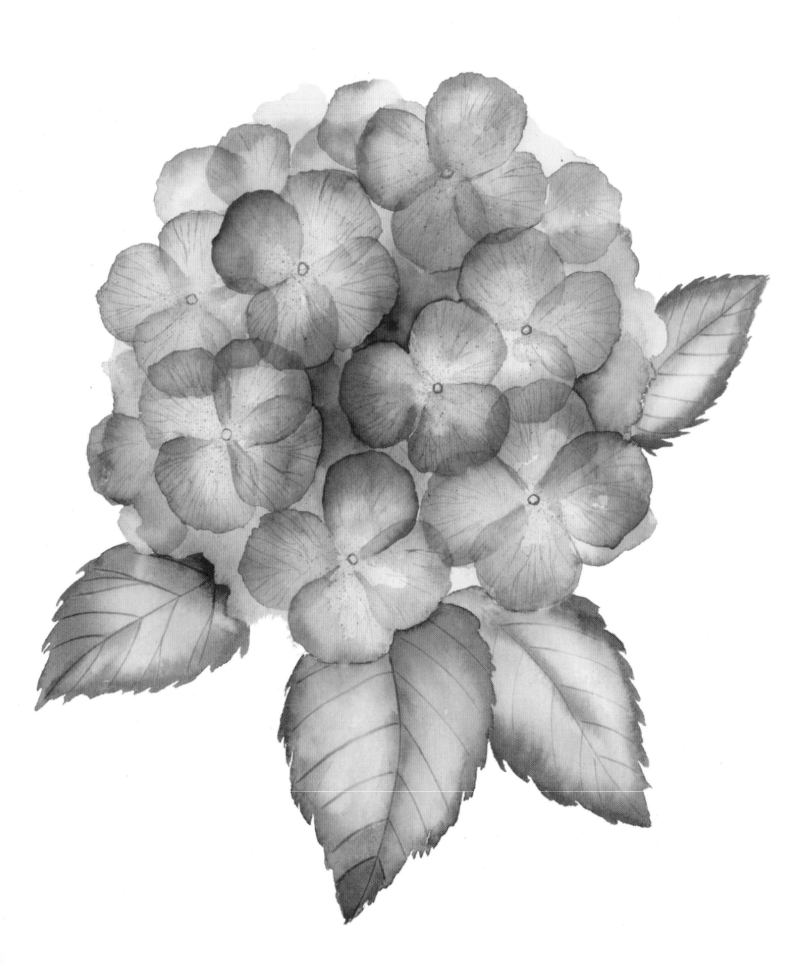

Hydrangea

TIP

Create swatches of new colors you create and keep them for your records. Write down what colors you combined and what ratios you used.

Stunning hydrangea flowers beg to be painted in watercolors! This painting looks complex but is actually quite simple. We'll take advantage of one of watercolor's most fascinating characteristics—transparency—and will practice the glazing technique to create a flower with an organic look.

A B C D E F G H

COLOR PALETTE

A. Blue (red shade) · B. Bright violet clear

C. Red-violet · D. Compose blue · E. Lemon yellow

F. Sap green · G. Deep sap green · H. Red-brown (opt.)

BRUSHES

Size 6 round

Size 10 round

Size 10/0 liner brush

Stiff brush

Small flat or angled brush

TECHNIQUES

Wet-on-wet wash (page 48)

Charging color (page 50)

Glazing (page 50)

Lifting color (page 51)

Negative painting (page 52)

Spattering (page 54)

OTHER SUPPLIES

9" x 12" (22.9 x 30.5cm) watercolor paper

Mechanical pencil with HB lead

Kneaded eraser

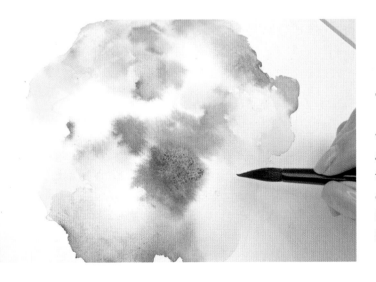

1 Lightly sketch the overall shape of the hydrangea and mark the centers with small circles. With a size 10 brush and clean water, wet the overall shape, then randomly drop in combinations of blue, compose blue, red-violet, and bright violet clear, leaving the centers bare. Let dry.

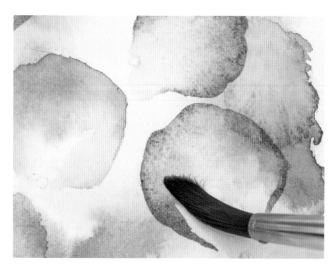

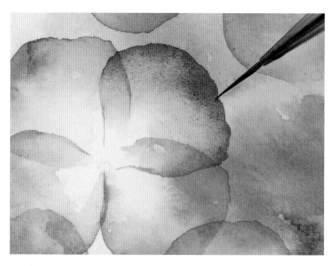

2 Switch to a size 6 brush and start painting the petals. Each flower will have four or five transparent petals that will overlap, so allow each petal to dry completely before painting a new one. Paint the outer edge of the petal with a light mix of violet, then, using a clean, damp brush, blend toward the center.

3 Before each petal dries completely, use a liner brush loaded with violet to charge more color and help define the irregular edges of the petals. Once you have painted all the petals, allow everything to dry.

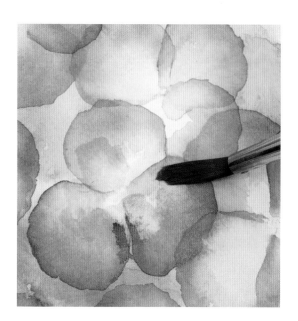

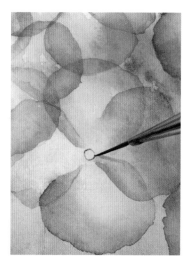

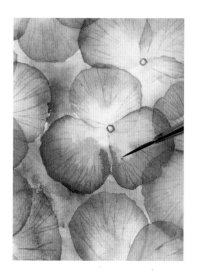

4 Create a watery mixture of mostly lemon yellow with a very small amount of compose blue. Gently glaze over the center of each flower. Let dry.

5 Use a liner brush loaded with red-violet to paint a small circle to define the center of the flower.

6 Using the paint mixtures on your palette, paint the veins of each petal. Use a very light version of the main color on each petal. Notice how the veins fade out before they hit the centers.

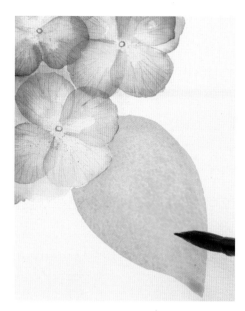

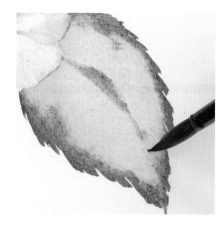

8 Before the sap green dries, and using a mixture of deep sap green and blue and the size 10 brush, paint the jagged edges of the leaves and a long stroke where the center vein of the leaf would be. Using a clean damp brush, "lift" paint to create a highlight.

7 Using a watery mixture of sap green, paint the base of the leaf with the size 10 brush.

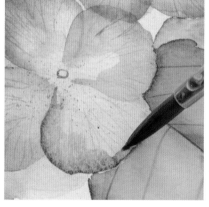

9 While still damp, use a small angled brush or any other pointed instrument to create the veins of the leaf. While the leaf is still damp, you can drop red-brown to give it some variation.

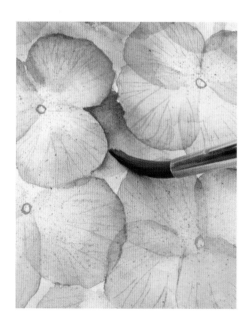

10 Using the negative painting technique, use a darker color to paint around some of the petals to help them stand out. Soften the edges with water to help blend with the rest of the background.

11 Evaluate your painting. If there are any petals you would like to emphasize, glaze over them as you did in Step 2. With a stiff brush, create tiny spatters in the center of each flower.

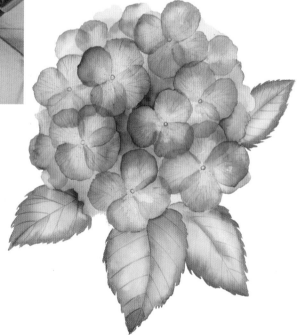

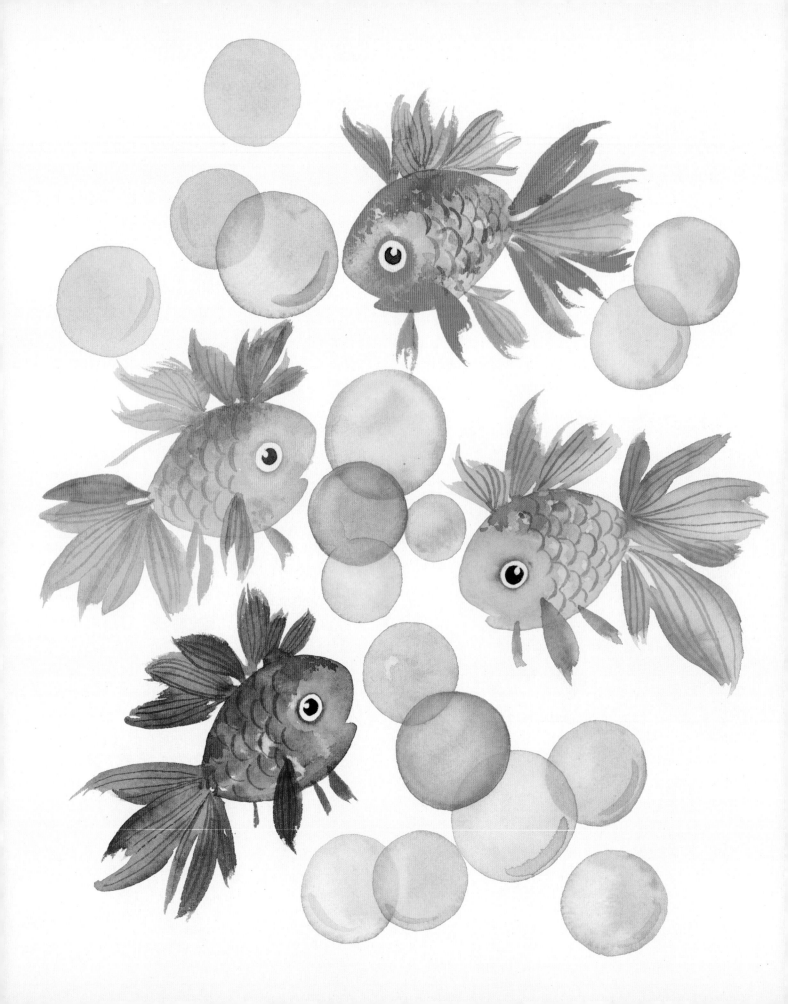

Whimsical Fish

There's something about colorful fish that just makes me smile, and I don't think I'm alone. And painting something simple and cute like this can put you in a good mood. Try painting a whole school of fish using colors that are close to each other on the color wheel.

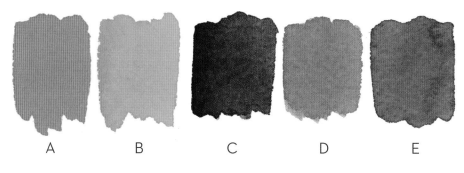

COLOR PALETTE

A. Bright opera • B. Yellow-orange

C. Indigo • D. Compose blue • E. Marine blue

BRUSHES
Size 2 round synthetic
Size 6 round synthetic
Size 8 round synthetic
Size 10/0 liner brush

TECHNIQUES
Flat wash (page 44)
Charging color (page 50)
Lifting color (page 51)
Scumbling (page 55)

OTHER SUPPLIES
Tissue paper
Old toothbrush
9" x 12" (22.9 x 30.5cm) watercolor paper
Mechanical pencil with HB lead

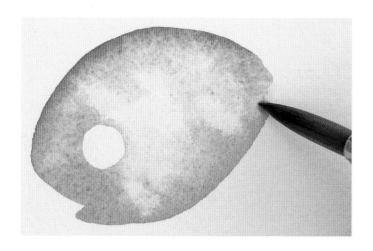

1 Begin by creating a soft outline of the body with the pencil. Pencil in the eye. With a size 6 brush, paint a flat wash of bright opera with a level 2 consistency (see page 32) over the body and around the eye. Using a slightly thicker consistency, charge the same color around the body and eye.

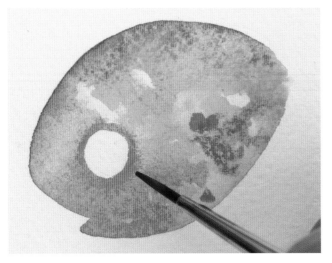

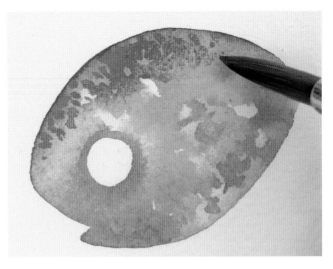

2 Use tissue paper to blot out some of the color. Let dry. Using the scumbling technique, paint another layer with a level 2 consistency of yellow-orange. Blot out any excess color with tissue paper. Let dry. Scumble a second layer with bright opera.

3 Add some small freckles over the top of the fish.

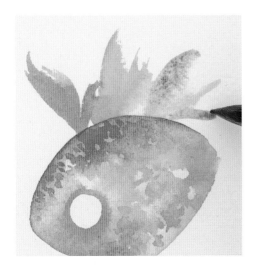

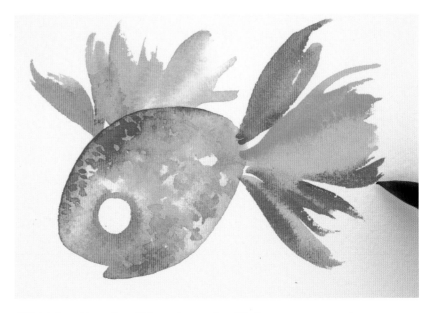

4 Load your size 6 brush with bright opera and paint in the dorsal fins. These are loose, expressive strokes. Rinse your brush, then paint another fin with yellow-orange. Use water to soften and help the colors blend.

5 Using the size 8 brush, and with loose, expressive strokes, paint the tail with bright opera and yellow-orange. Use water to help blend.

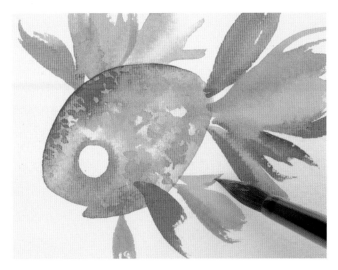

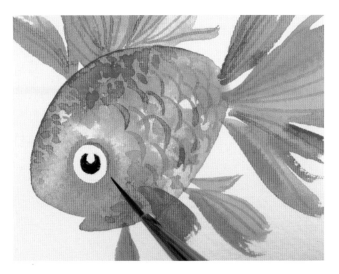

6 Using the size 6 round brush, paint the smaller fins over and behind the belly.

7 Use the liner brush and bright opera to paint the detail lines over the fins and the scales. Lastly, paint the eye with indigo.

8 Let's paint some bubbles! Begin by lightly drawing the outline. Using compose blue, create a small puddle with a level 1 consistency. With a size 8 brush, paint the lightest value, leaving the highlights bare. Soften the highlights with a clean, damp brush.

9 Once the paint has lost its sheen, using your size 6 brush, charge a little marine blue around the outer edge and toward the bottom and middle area. Blend with a clean, very damp brush. Let dry.

10 Add more bubbles. You can layer one bubble over the other but make sure that the bottom one is dry.

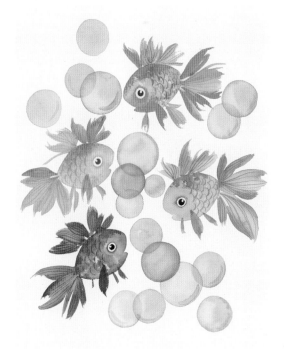

Have fun with color and create a whole school of whimsical fish!

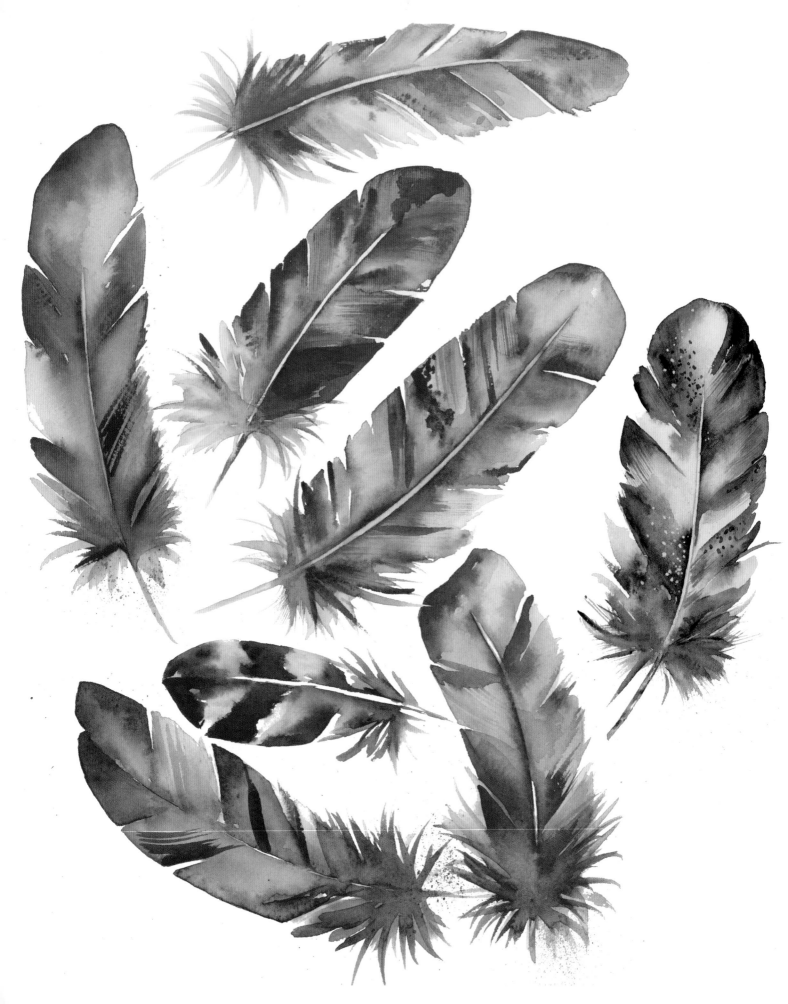

Fabulous Feathers

Feathers vary so much in shape, size, color, and type that I never get tired of painting them. For this project, we're not going to paint a realistic-looking feather; instead, we will have fun with bleeds, blends, and expressive strokes. The possibilities are endless!

BRUSHES

Size 2 round synthetic

Size 8 round synthetic

Small angled brush

TECHNIQUES

Flat wash (page 44)

Gradated wash (page 46)

Lifting color (page 51)

Dry brush (page 54)

Glazing (page 50)

Negative painting (page 52)

Spattering (page 54)

OTHER SUPPLIES

White gouache (optional)

9" x 12" (22.9 x 30.5cm) watercolor paper

Mechanical pencil with HB lead

COLOR PALETTE

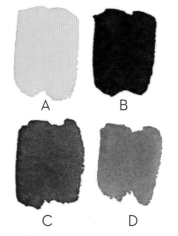

A. Transparent orange

B. Indigo

C. Van Dyke brown

D. Bright violet clear

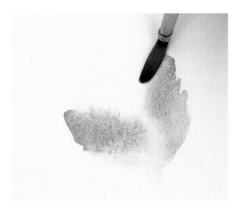

1 Lightly draw the overall shape. Mix a puddle of bright violet clear and one of transparent orange with a level 1 consistency (see page 32). Using a size 8 brush, paint the middle section with each color. Soften the edges with water and a clean, damp brush.

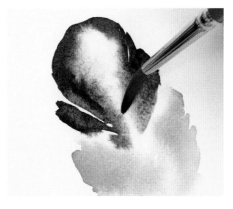

2 Mix a puddle of indigo with a level 2 consistency and begin painting the top section. Paint the outline and then quickly blend out with a clean, damp brush. Lift color for the rachis (stem) of the feather.

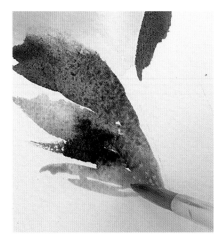

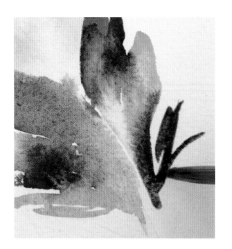

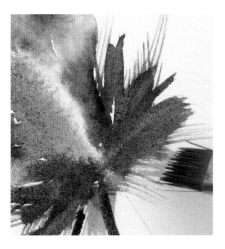

3 Paint the bottom section with indigo. Add a small amount of Van Dyke brown paint on one side of the rachis (stem). Then, with a clean, damp brush, create loose, outward strokes. Drop more pigment in some areas.

4 As you reach the bottom portion, the barbs should get shorter. Use loose strokes to paint these smaller afterfeathers with indigo.

5 Once you have reached the bottom of the vane, use the dry-brush technique and a fairly dry angled brush to pull out paint with swift, loose strokes to create the downy barbs. Let dry.

TIP
Avoid mixing the colors with your brush or you will create "mud." Use a paper towel to blot out unwanted color mixes.

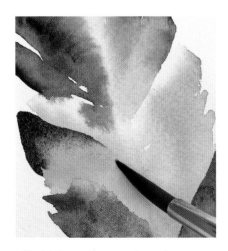

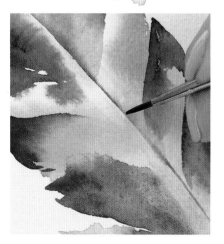

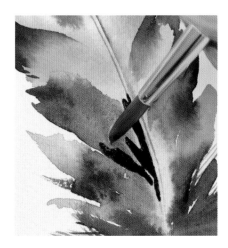

6 Using the gradated wash technique, define some of the barbs. Paint indigo color over the light transparent orange section with the size 8 brush.

7 Using negative painting, define the stem. Using a size 2 brush, paint a line in the center. Then with a clean, damp, size 8 brush, soften this line, blending toward the right side. Repeat on the other side.

8 Once the rachis is painted, you can define it even further by adding more paint on each side with the size 8 brush. Soften any hard edges with clean water.

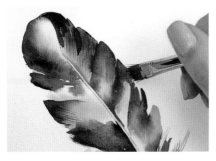

9 Time to evaluate your painting and decide if you want to add some more defined barbs (see Step 8). Using the dry-brush technique, add some light strokes with the angled brush.

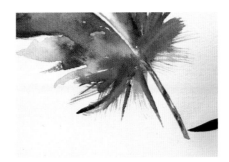

10 Paint the quill of the feather with the size 2 brush and a light indigo color. Before it dries completely, drop in a little Van Dyke brown to give it depth and texture.

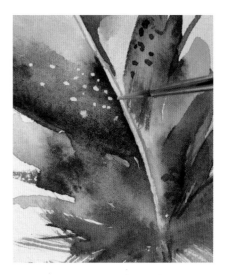

11 Once everything has dried completely, add some final details. With the size 2 brush, paint small dots in some areas with indigo paint and more dots with white gouache.

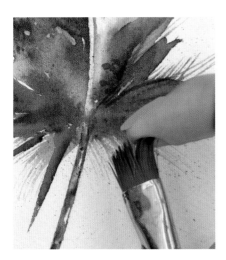

12 This step is optional, but I like to finish my feather painting with a few little spatters!

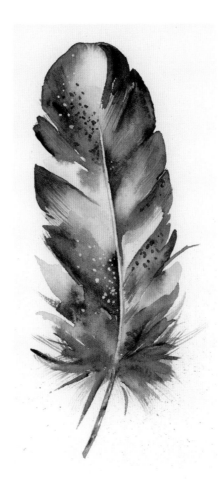

TIP
When using the dry-brush technique, test the stroke on a scrap piece of paper to make sure the brush isn't too wet or too dry.

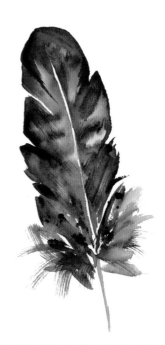

ANOTHER APPROACH
You can also use the same method but with a monochromatic color scheme (see page 33). This one was done only in different values of indigo.

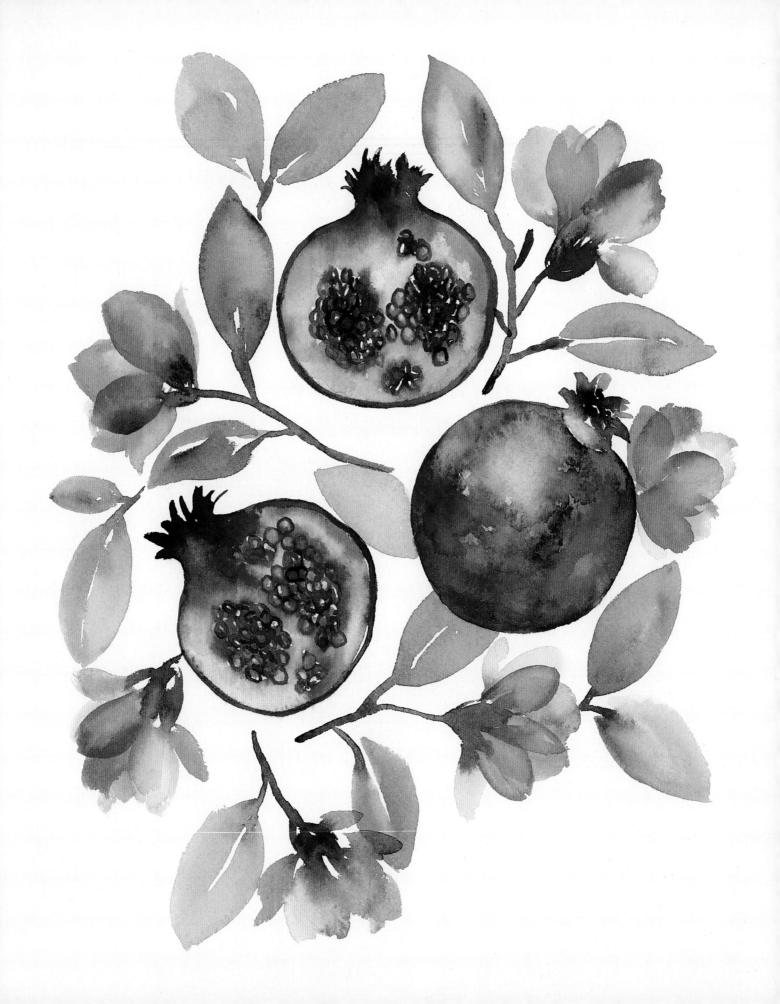

Pomegranates and Blossoms

Painting fruit is a great way to explore color, texture, and form! Simple shapes can be turned into deliciously juicy slices of fruit that are fun and refreshing to paint—especially during the hot summer months!

COLOR PALETTE

A. Indigo • B. Permanent magenta • C. Purple (custom mix of indigo and permanent magenta) • D. Rose madder • E. Transparent orange

F. Quinacridone red • G. Van Dyke brown

H. Olive green • I. Raw sienna

BRUSHES

Size 2 round synthetic

Size 6 round synthetic

Size 8 round synthetic

TECHNIQUES

Flat wash (page 44)

Charging color (page 50)

OTHER SUPPLIES

11" x 14" (27.9 x 35.6cm) watercolor paper

Mechanical pencil with HB lead

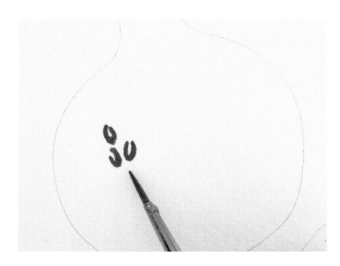

1 Lightly sketch each pomegranate. Leave room for the flowers and leaves. With permanent magenta in a level 2 consistency (see page 32) and a size 2 brush, paint the seeds. They should be tiny open ovals going in different directions. Let dry.

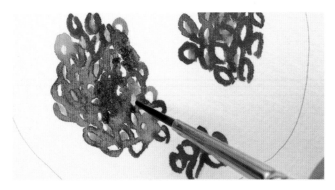

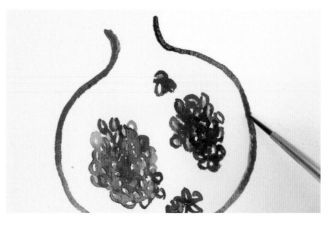

2 Using a clean, damp brush, gently soften some of the seeds so not all of them have a white center. On your palette, create a mixture of indigo and permanent magenta to achieve a rich purple. Drop in a small amount in some areas.

3 With a size 2 brush, paint the skin of the pomegranate slice using permanent magenta and dropping in a little of the purple mixture you created.

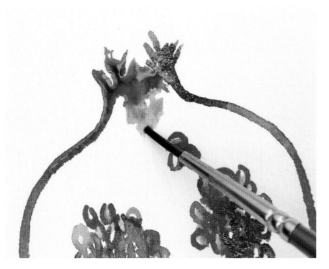

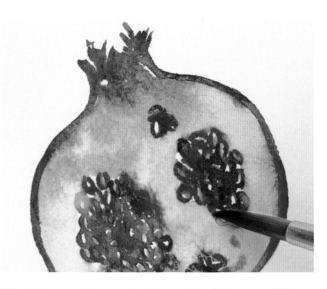

4 Place a small amount of raw sienna over the fruit's calyx. It looks like a little crown.

5 Using a clean size 8 brush with very little water, begin painting the flesh of the fruit by barely touching the skin and painting around the seeds. Colors will start to bleed, giving the skin a delicate, pinkish tone. Blot out areas that are too saturated with a clean, damp brush. Drop in a watery mix of transparent orange.

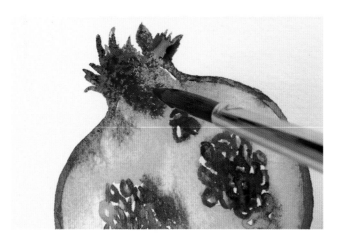

6 Drop in some rose madder paint to give the calyx a little more contrast.

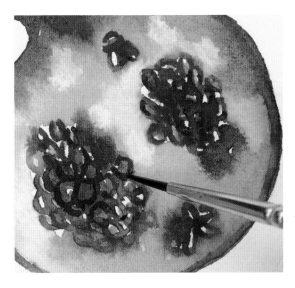

7 Switch back to the size 2 brush and paint some more open oval shapes with your purple mixture to define some more seeds.

TIP
Instead of using your brush to help colors blend, drop colors and allow them to mingle on their own.

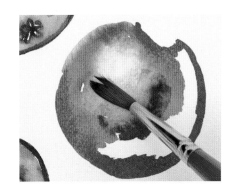

8 With the size 8 brush, paint in the basic strokes of the skin with permanent magenta (left stroke), purple (center right), and rose madder (right and top) to identify where the highlights and the shadows will be. Use a damp brush to soften the edges and create the lighter values as you approach the highlights.

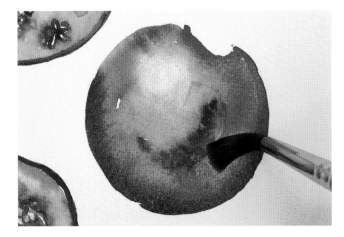

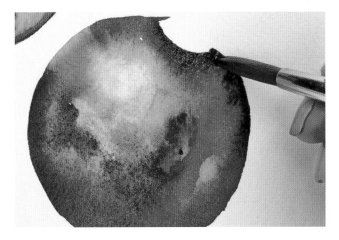

9 Drop more rose madder to the right side of the fruit and charge purple paint on the bottom of the fruit to give it more depth.

10 While the fruit is still damp, drop in some brown to give it a leathery texture. Charge purple toward the top and right to create depth and dimension.

11 Begin to paint the calyx of the fruit with raw sienna. Once it dries to a matte finish, drop in Van Dyke brown.

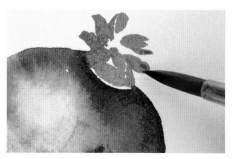

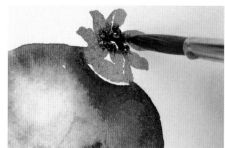

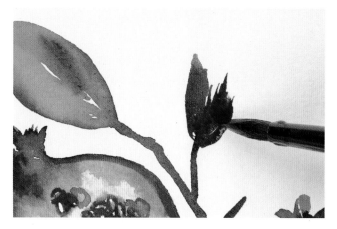

12 With the size 6 brush, paint leaves, branches, and blossoms to finish.

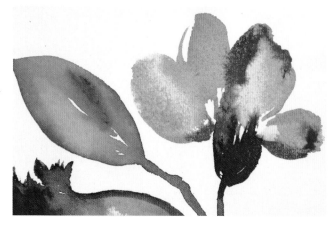

13 Paint loose flowers with a watery mix of transparent orange and quinacridone red. Notice how the base of the flower is the same magenta color used on the pomegranate.

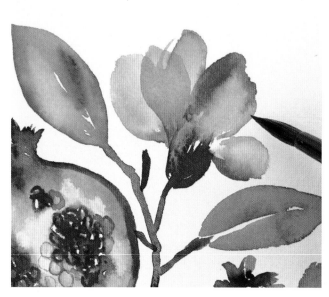

14 Once your first layer of petals is dry, you can add some transparent petals on top to make the flower look fuller.

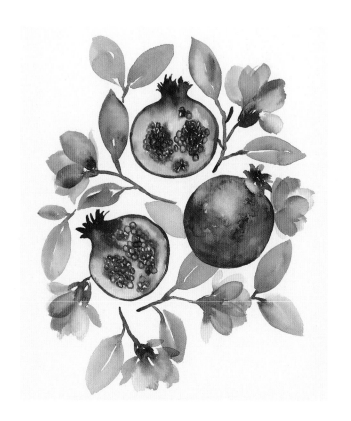

Fall Leaves

I was born and raised most of my life in Guatemala, a country that's often referred to as "the land of eternal spring." There really isn't a big difference between seasons there, so now, living in North Texas, I've come to appreciate fall, and an earthy color palette takes over my work.

BRUSHES

Size 2 round synthetic

Size 8 round synthetic

Size 10/0 liner brush

TECHNIQUES

Flat wash (page 44)

Charging color (page 50)

Lifting color (page 51)

Blooms (page 53)

Glazing (page 50)

OTHER SUPPLIES

Leaf templates (page 133)

9" x 12" (22.9 x 30.5cm) watercolor paper

Mechanical pencil with HB lead

Brush with beveled handle or toothpick

COLOR PALETTE

A. Raw sienna • B. Burnt sienna • C. Red-brown

D. Van Dyke brown • E. Sap green • F. Hansa yellow light

G. Yellow-orange • H. Vermilion

WHITE OAK LEAF

1 Lightly trace the leaf template. Mix a small puddle of raw sienna with a level 1 consistency (see page 32), and with a size 8 brush, paint the leaf with a light flat wash. Charge around the edges with burnt sienna.

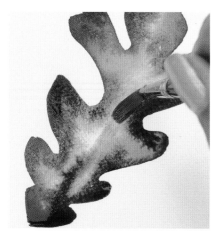

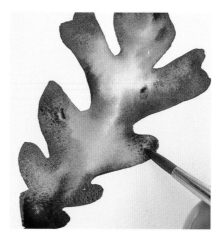

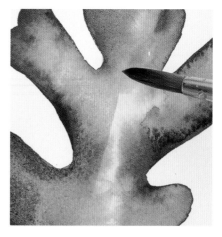

2 Drop raw sienna in some areas. Charge red-brown and burnt sienna all around the edges. With a clean damp brush, lift color toward the center.

3 Charge Van Dyke brown in some areas to create more depth and texture, adding random spots if desired. Create a bloom with a clean water droplet. Let dry.

4 Build up more color by glazing with a very light wash of raw sienna over one side of the leaf. Be gentle so you don't disturb the layer underneath. Use mostly water when you reach the upper half. Let dry.

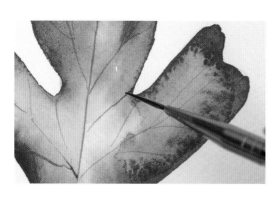

5 Paint in the veins with Van Dyke brown using a liner brush and a level 2 consistency.

PEAR LEAF

1 Trace the leaf template. Begin by mixing a small puddle of Van Dyke brown with a level 3 consistency. Using the size 8 brush, paint small jagged edges on the left side of the leaf and then quickly soften the inner edge with water and a clean, damp brush.

2 With sap green, paint right next to the color you just smoothed out. Don't overwork it! Allow colors to mingle on their own. With a clean, damp brush smooth out the green you just painted to soften the hard edge.

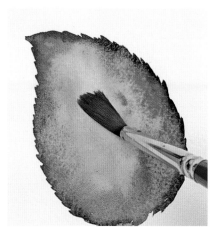

3 Pick up some raw sienna, paint a stroke, and smooth it out with a clean, damp brush. Move to the other side of the leaf, paint a stroke with sap green, and smooth it out.

4 Paint the jagged edges using Van Dyke brown and smooth it out with a clean damp brush. Notice that the green will begin to blend in.

5 While the leaf is still wet, paint a few spots with green. Using a clean, damp brush and with a bold stroke, lift paint in the center to create a highlight.

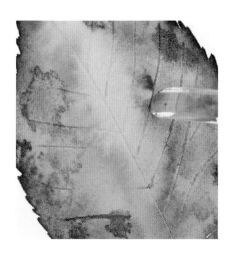

6 While still damp, add a few dots of vermilion. Notice there isn't much spreading, and that's okay! Use a brush that has a beveled handle to create the veins of the leaf. If you don't have one, use a toothpick. Let dry.

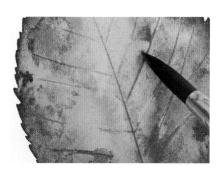

7 Add a light wash of raw sienna plus a few more drops of green to create more texture.

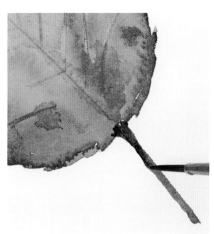

8 Using Van Dyke brown and the liner brush, paint in the stem. Use a thicker consistency toward the top to give it depth.

9 Add some final details such as dark brown spots over the vermilion dots and some smaller ones toward the edges.

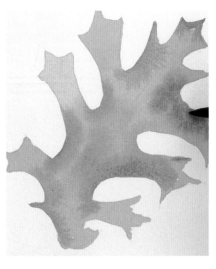

PIN OAK LEAF

1 Trace the leaf template. Using a light wash of Hansa yellow light and a size 8 brush, paint one half of the leaf.

2 Drop in a little yellow-orange paint.

3 Paint the other side of the leaf the same way. Allow this first layer to dry.

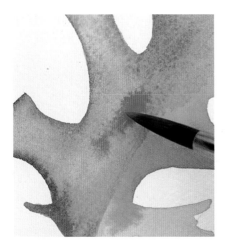

4 Build up color by painting a second layer, one side at a time. Paint a light wash with Hansa yellow light and, with a size 2 brush, charge yellow-orange, burnt sienna, and vermilion one color at a time and in different areas to create the darker values.

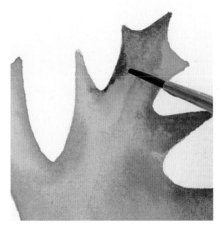

5 Take a moment to evaluate your painting before it dries completely and charge Van Dyke brown in some edges and corners to mimic the drier parts of the leaf.

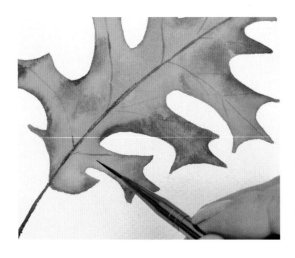

6 Finish your pin oak leaf by painting the veins and stem with the liner brush and Van Dyke brown.

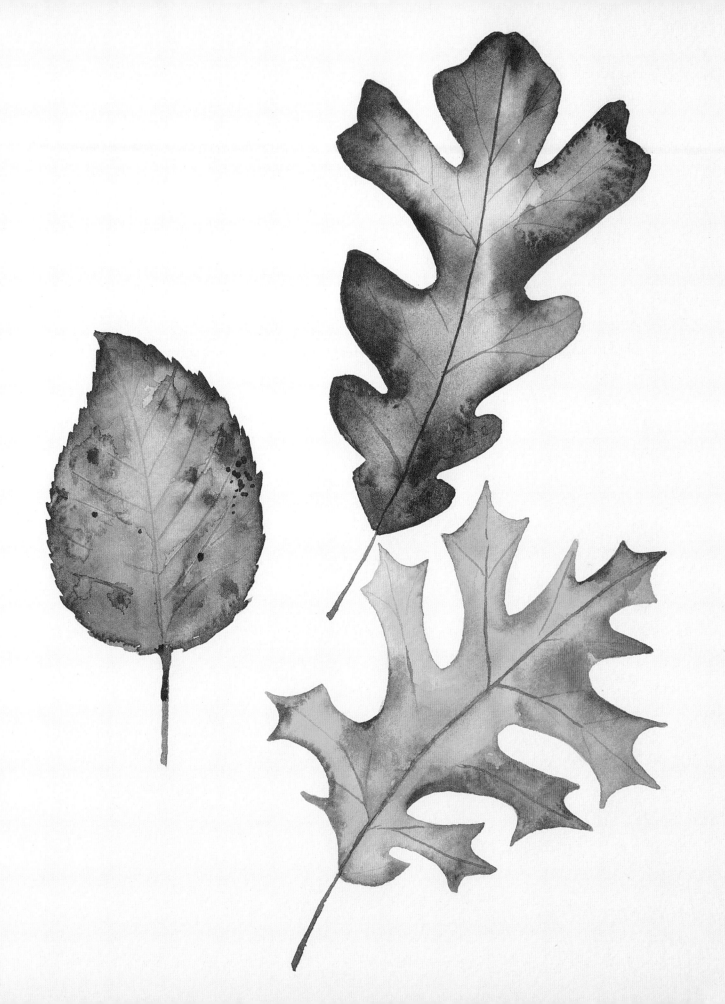

Home

State Pattern Play

For this project, I'll show you how to paint an allover pattern in the shape of a state. I chose my home state of Texas, but you can adapt it to any state with any pattern. Simply look at a map or search online to find a state silhouette. I chose bluebonnets as they're the state flower of Texas, but you can paint geometric shapes, abstract textures, or anything that reminds you of home.

BRUSHES

Size 2 round synthetic

Size 8 round synthetic

TECHNIQUES

Masking (page 51)

Brush lettering (page 56)

OTHER SUPPLIES

9" x 12" (22.9 x 30.5cm) watercolor paper

Lightpad (optional)

Mechanical pencil with HB lead

Kneaded eraser

Liquid frisket (masking fluid)

Tool to apply the liquid frisket (or old brush that has been rinsed in soapy water)

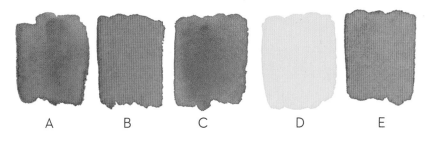

A	B	C	D	E

COLOR PALETTE

A. Sap green • B. Permanent magenta • C. French ultramarine

D. Lemon yellow • E. Pyrrol scarlet

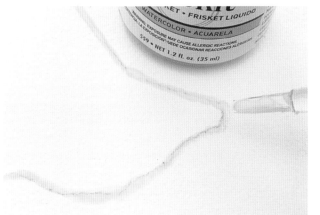

1 Lightly draw the outline of the state of your choice and the word "home." Apply the liquid frisket over the pencil outline of the map. Let dry.

TIP

Pour a little of the liquid frisket into a small container with a lid. This way your original container will last longer.

2 Paint a bluebonnet. Using a size 2 brush and a level 2 paint consistency (see page 32), paint little buds and the stem. Use sap green toward the top, lemon yellow toward the bottom of the buds, and sap green again for the stem. Let it dry.

3 Using a level 3 consistency and the size 8 brush, paint petals with ultramarine. While this flower dries, paint more like these all over the state. Make sure they go in different directions. Imagine you tossed a bunch of these and they fell randomly.

4 Go back to the first flower, and with a clean, damp brush, touch one of the buds you already painted to create the lighter petals. Your brush shouldn't be too wet as you don't want water spreading over the other petals. Repeat this step for the rest of your flowers.

5 Once your flowers have dried, paint a small dot in some of the lighter petals with permanent magenta. Do this for all the flowers.

6 Using sap green, paint small, curved leaves. Paint dotted circles with ultramarine, small flowers with pyrrol scarlet, and leafy marks with a watery mix of ultramarine. Paint elements along the edges to define your state.

8 Once everything has dried completely, carefully peel off the liquid frisket. Paint any additional elements along the inner edges if you notice any big gaps. Gently erase the pencil outline.

7 Using a level 2 consistency, paint the word "home" with the size 2 brush. Try to paint the downstrokes thicker than the upstrokes. You can paint right over the pencil lines if your lines are very faint.

This project can be used as a moving away or housewarming gift.

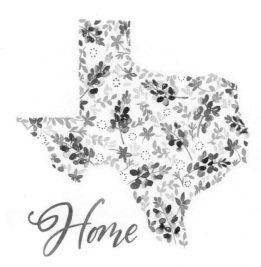

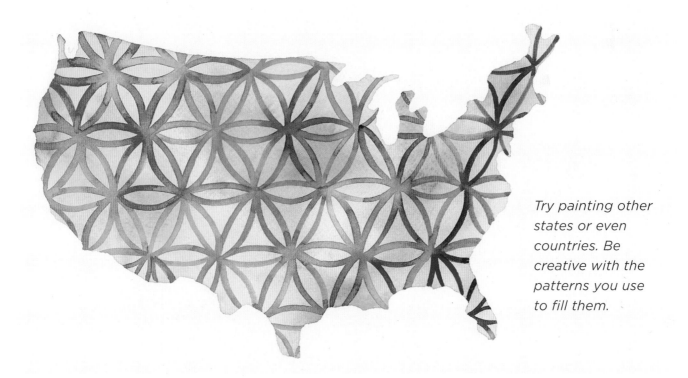

Try painting other states or even countries. Be creative with the patterns you use to fill them.

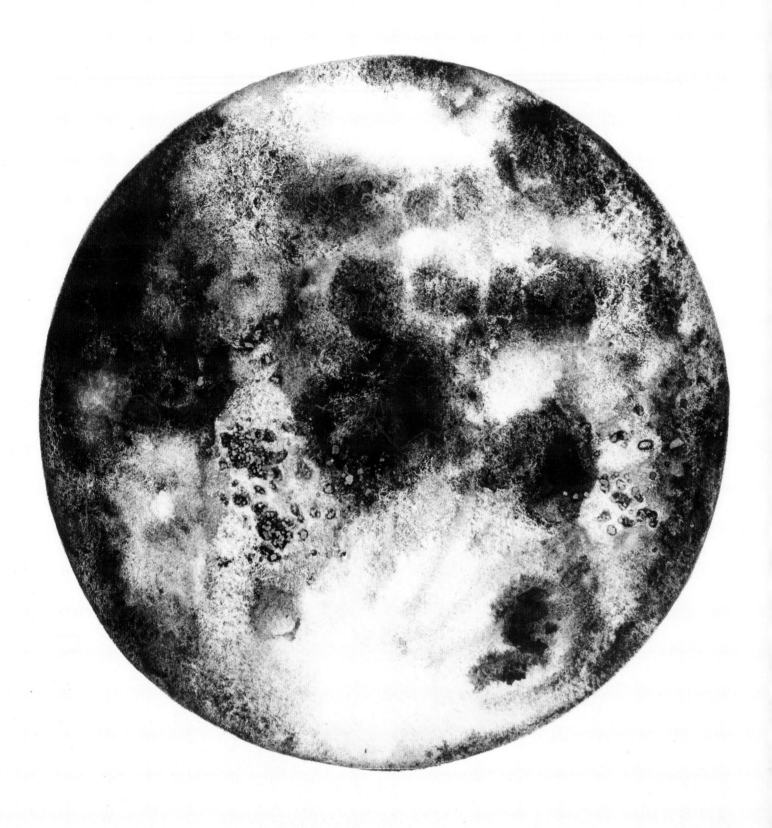

Monochromatic Moon

I know you love color variety as much as I do! But there's something exciting about painting with only one color—even black. For this project, we will incorporate a few techniques to achieve texture, but I recommend you use granulating black paint as the texture it produces is hard to replicate! The more water you use, the more you will see its granulating effect.

BRUSHES

Size 2 round synthetic

Size 6 round synthetic

Size 8 round synthetic

Mop brush (or size 12 round synthetic)

TECHNIQUES

Wet-on-wet wash (page 48)

Charging color (page 50)

Lifting color (page 51)

Salt texture (page 53)

OTHER SUPPLIES

9" x 12" (22.9 x 30.5cm) watercolor paper

Compass

Mechanical pencil with HB lead

Tissue paper

Coarse salt

COLOR PALETTE

Granulating black

TIP
The wetter the paper, the more the paint will spread and the harder it will be to control, so don't start with a huge puddle on your paper. You can always add more.

1 Using a compass, draw a circle about 6" (15cm) in diameter. Prepare a puddle of black paint with a level 2 consistency (see page 32). Using a large mop brush and clean water, wet your entire circle, getting as close to the edge as possible but not quite touching the pencil mark.

2 Using a size 8 brush and black paint, paint the outline of the circle as you gently touch the wet area of the circle. Notice you are producing a hard edge on one side and a soft edge on the other. If the moon begins to dry, add a little more water with your clean brush. During this stage, your moon should remain a glossy moisture level.

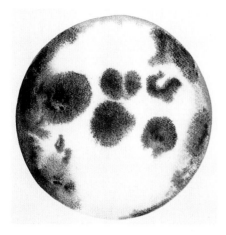

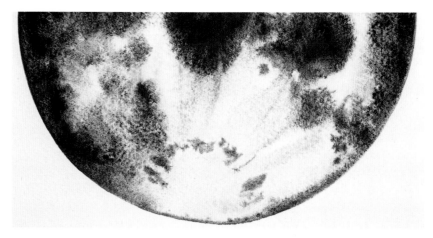

3 Charge paint on the left side of the moon to make the darker values. Drop paint in some areas for the darkest areas of the moon.

4 The lightest areas of the moon are impact craters, caused by asteroids, comets, and meteorites. Work around these main areas to maintain the white of the paper. Use tissue paper to lift any unwanted paint. Use a clean, damp size 2 brush to make some soft gray lines that emanate from these craters.

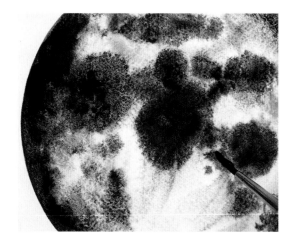

6 For texture, create blooms in some areas by adding a few drops of clean water and add coarse salt in others. Let dry completely then gently remove the salt.

5 Using the size 6 brush, drop paint around some of the darker large areas to create the rocky surfaces.

Word Art

Painting letters, words, and phrases is a great way to create visual reminders of things that inspire us. Find a font that has thick letters, as in this example. Type the word that you want to paint, print it large, and use it as a template. I decided to use the word "goals" to help keep me inspired. One of my goals is to never stop learning. What are some of yours?

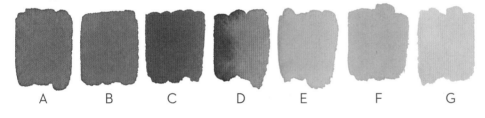

COLOR PALETTE

A. Viridian • B. Blue (green shade)

C. Bright violet clear • D. Permanent magenta

E. Yellow-orange • F. Transparent orange • G. Lemon yellow

BRUSHES

Size 1 round synthetic

Size 8 round synthetic

TECHNIQUES

Gradated wash (page 46)

Variegated wash (page 47)

Lifting color (page 51)

Salt texture (page 53)

OTHER SUPPLIES

9" x 12" (22.9 x 30.5cm) watercolor paper

Lightpad (optional)

Mechanical pencil with HB lead

Kneaded eraser

Coarse salt

Straw (optional)

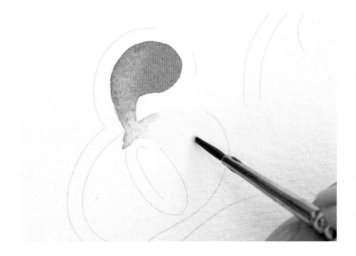

1 Lightly trace the letters and outline of the word. Create seven small puddles of different paints with a level 2 consistency (see page 32). Work in rainbow order to avoid creating "mud." Using a size 1 brush, begin to paint your first letter. Begin with permanent magenta, then orange, then lemon yellow.

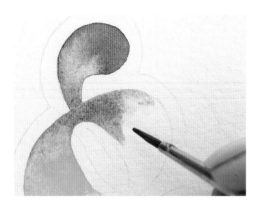

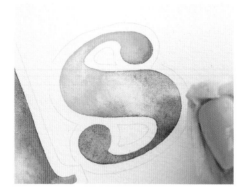

3 As you paint, use water to create different values even within the same color. This will give your letters that playful watercolor look. Lift paint in some areas to create highlights and texture.

2 Notice that as you go down this letter, you no longer have one leading (active) edge, but two. To buy some time, keep one of the edges moist by adding paint or softening it with a little water while you work on the other side.

TIP
Some strokes can feel awkward going in a certain direction, in this case the circular shape. Try rotating your paper if it helps you paint more easily.

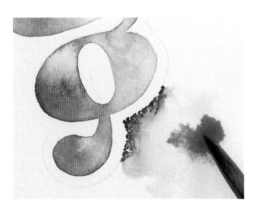

4 Allow the letters to dry. Using bright violet clear with a level 3 consistency and the size 1 brush, paint small dots that are close to each other to create the outline. Using a damp size 8 brush, touch the little dots to soften the edges and create the background. Drop some magenta and bright violet clear in some areas.

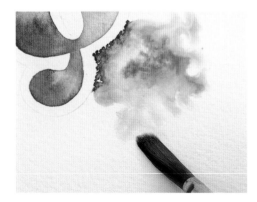

5 Use water to soften the edges. We're going for a "splashy" background, so leave the edges uneven.

6 Add some coarse salt in some of the areas you've already painted to create texture!

8 If you're feeling adventurous, use a straw and blow some of the paint outward to create splashes.

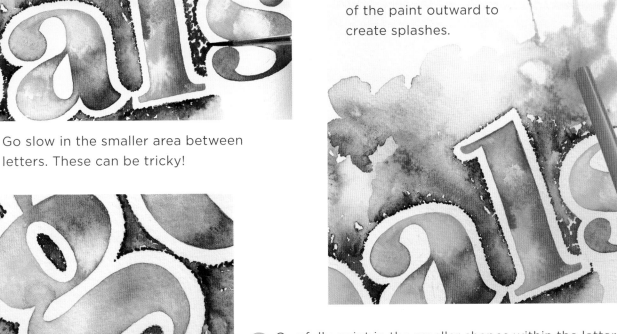

7 Go slow in the smaller area between letters. These can be tricky!

9 Carefully paint in the smaller shapes within the letters to give it a more finished look and to help the word pop. Allow everything to dry completely and remove the salt.

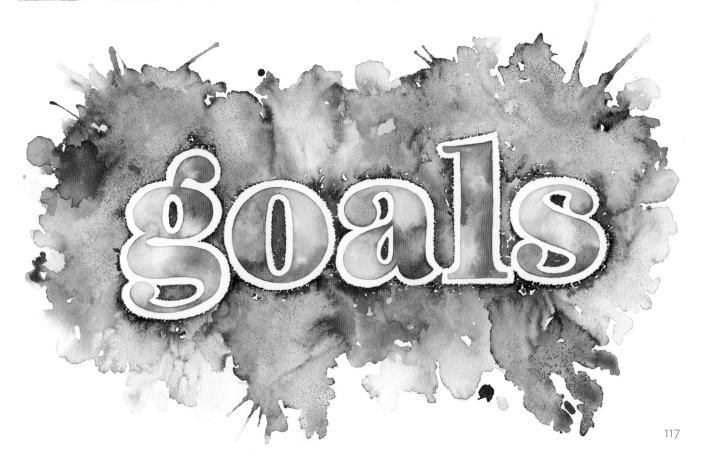

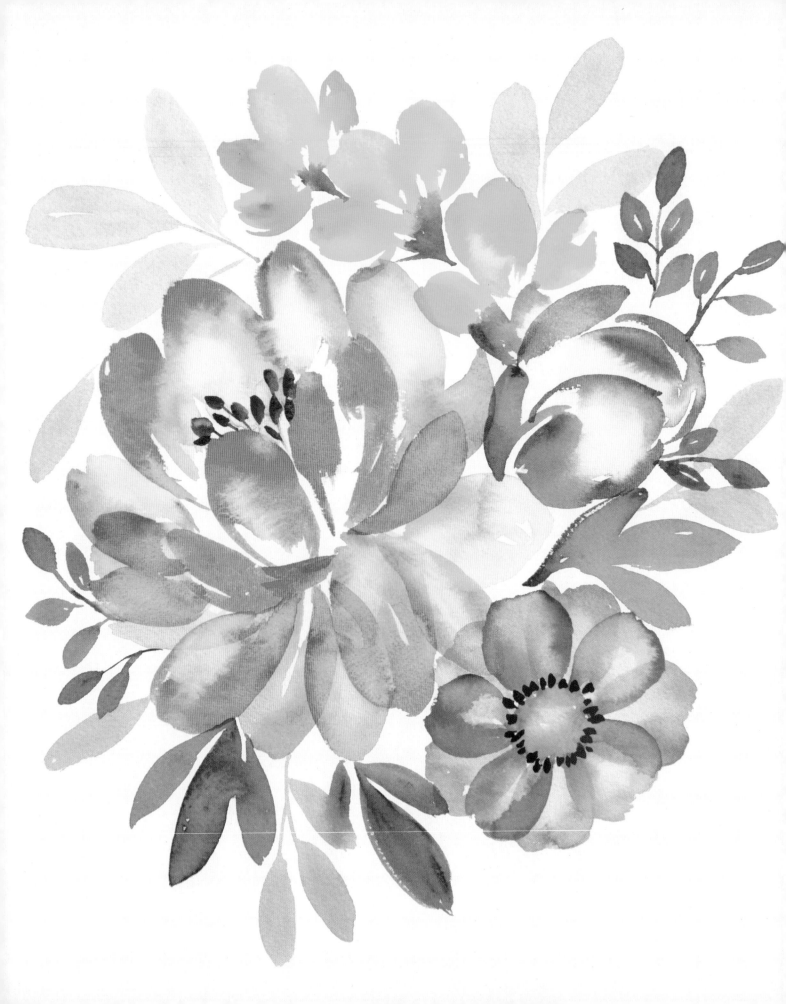

Painting Loose-Style Florals

I have always admired the simple beauty of a bouquet of flowers. I can't always have fresh-cut flowers, but I feel equally happy when I paint a bouquet of watercolors. Loose watercolor florals are seen everywhere now—on wedding invitations, paper plates, product packaging, and so much more.

BRUSHES

Size 2 round

Size 8 round

Size 12 round

TECHNIQUES

Flat wash (page 44)

Charging color (page 50)

Scumbling (page 55)

OTHER SUPPLIES

10" x 14" (26 x 36cm) watercolor paper

Mechanical pencil with HB lead

Kneaded eraser

COLOR PALETTE

A. Bright opera • B. Red-violet • C. Vermilion

D. Yellow-orange • E. Hansa yellow light

F. Marine blue • G. Compose blue • H. Sap green

I. Olive green • J. Burnt umber • K. Van Dyke brown

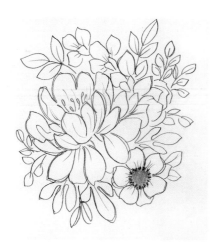

1 Begin with a pencil sketch. Focus on the overall shapes of the flowers, not the details. After you decide where the main flowers will go, add some filler flowers and leaves.

2 To paint a peony, mix a small puddle of bright opera with a level 3 consistency (see page 32) and small puddles of vermilion and yellow-orange at level 2. With a size 8 brush, paint the three petals at the center of the peony with bright opera. Use a clean, damp brush to paint the lighter values.

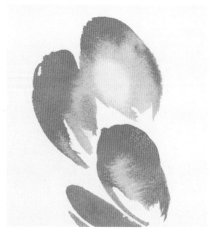

3 With bright opera, paint another petal, leaving a small gap between the two so they don't blend completely. Blend out the centers with a clean, damp brush and charge a small amount of vermilion on one side of the petal. Drop in a small amount of yellow-orange toward the center of these petals.

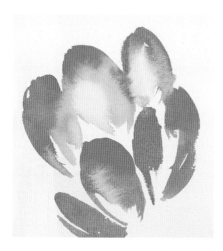

4 Add more petals. These are expressive strokes, so paint with swift strokes. Leave space between petals so they don't become one big blob.

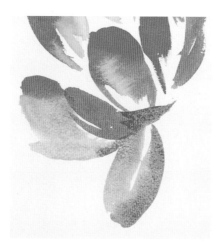

5 Using yellow-orange with a level 2 consistency, paint a petal on the left side of your flower and one on the bottom portion. Charge vermilion on the tip of the top petal and bright opera on the bottom.

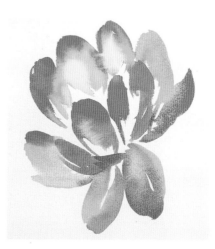

6 Paint another yellow-orange petal on the right that looks like it's behind the other petals. And then a long, narrow petal with bright opera. Paint another wider petal toward the bottom.

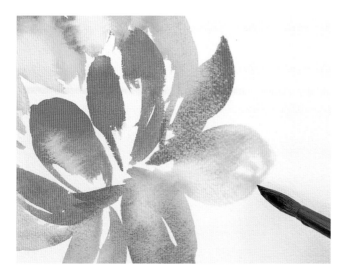

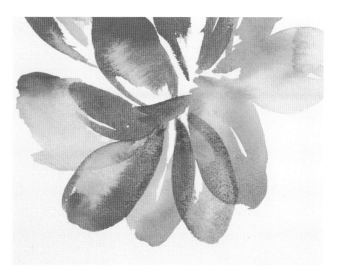

7 Using a clean, damp brush. paint a softer-looking petal on the bottom right side by pulling color from that top petal. Don't forget to charge vermilion on the yellow-orange petals you painted in the last step. Let dry.

8 Now paint some additional petals that are layered over the already dry ones. Paint the outline of the petal with bright opera, then, with a clean, damp brush, soften the inside of the petal. You can still see some of the petals underneath.

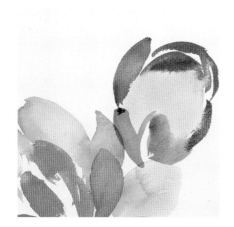

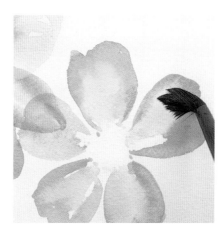

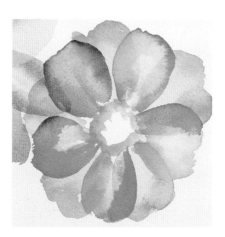

9 Now we will paint a bud. Using a size 12 brush, pick up some sap green with a level 2 consistency and paint a few strokes. With red-violet, paint the top and side petals. With a clean, damp brush, blend out and soften the top inner strokes. Let dry.

10 Using sap green and a size 8 brush, paint a dotted circle for the center of the teal flower. With compose blue and a level 2 consistency, paint five petals. Lift color with a clean, damp brush to create highlights. Let dry.

11 On your palette, add a little marine blue to your compose blue mix. Using a size 8 brush, paint five petals that overlap the bottom ones. Drop in a little sap green for variation. Scumble a sap green ring around the center and soften with water.

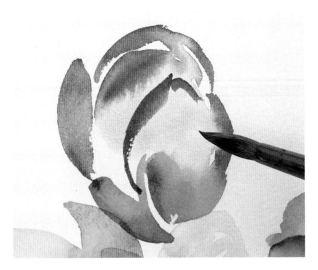

12 Go back to the bud and paint another petal over the mostly white middle area. Using a clean, damp brush, blend out one side of the petal. Try not to touch the green part too much.

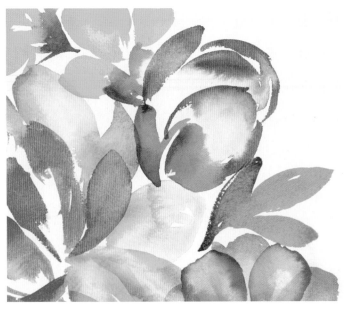

13 Using Hansa yellow light with a level 3 consistency, paint smaller, filler flowers. Use sap green to paint stems and leaves for each flower.

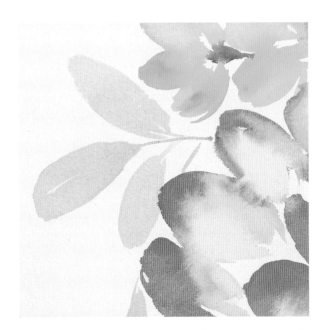

14 Using a watery mix of sap green and olive green, paint some lighter leaves.

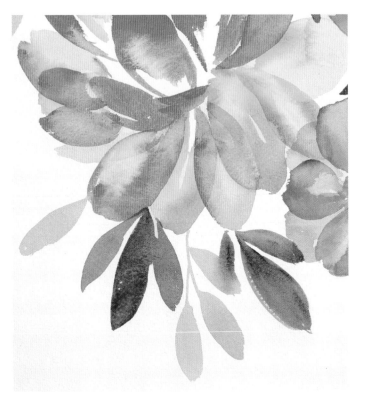

15 Use sap green to paint the peony leaves.

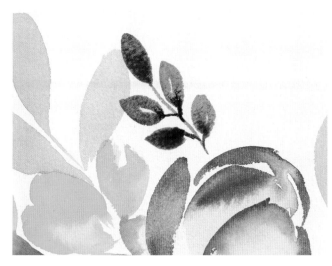

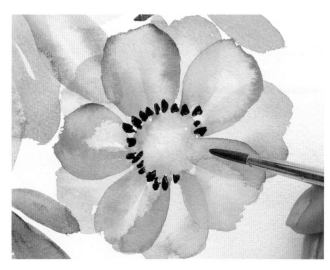

16 Let's add a few more details to this painting. Using the size 2 brush, paint some tiny filler leaves with sap green and burnt umber. Let everything dry completely.

17 Lastly, using a thick mixture of Van Dyke brown and burnt umber, paint the stamen on the center of the teal flower and the peony.

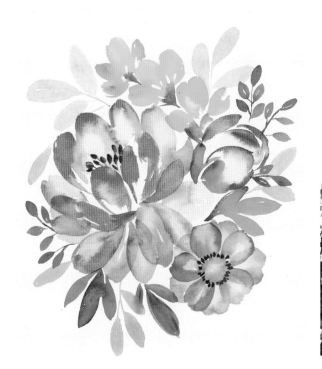

FLOWER STUDIES

I recommend you first spend time familiarizing yourself with the overall shapes of different flowers. I like to visit botanical gardens and always take pictures for reference. One of my favorite places to find #floralinspiration is Instagram! There are endless accounts that post beautiful photos of flowers and bouquets! I also follow #ihavethisthingwithflowers. It has helped me find some amazing flower farmers. You can look for inspiration on Pinterest or pick up a few books on floral arrangements and floral design. Once you find a flower photo you like, use tracing paper and a felt-tip marker to draw a simplified version. This will help you break down each flower to its basic components.

Alessandra

Monogram

Personalized monograms are a great gift idea, and there are several ways to create them. One of my go-to methods is using a letter cutout and a watercolor background painting. For the background, you can choose a floral theme or an abstract watercolor. I use everything in my toolbox to create texture: water blooms, salt, spatters, lifting, and even my heat tool.

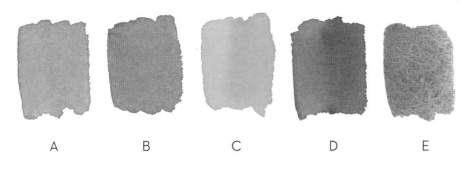

COLOR PALETTE

A. Viridian • B. Compose blue • C. Sap green

D. Marine blue • E. Gold gouache

BRUSHES

Size 2 round synthetic

Mop brush (or size 12 round synthetic)

Small angled brush

TECHNIQUES

Wet-on-wet wash (page 48)

Salt texture (page 53)

Brush lettering (page 56)

OTHER SUPPLIES

For watercolor background: 10" x 14" (26 x 36cm) watercolor paper

Sturdy surface (optional)

Painter's tape (optional)

Metallic watercolors

Heat tool

Coarse salt

For letter cutout: 9" x 12" (22.9 x 30.5cm) watercolor paper

Craft knife

Lightpad (optional)

Double-sided tape

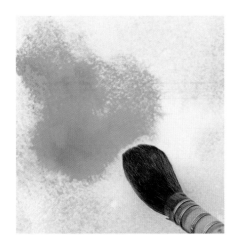

2 Pick up some metallic watercolors and randomly place throughout your painting. Colors are very subtle but once it dries, it leaves a beautiful pearlescent effect on your paper.

1 To prevent buckling, tape your background paper to a flat surface or use a watercolor block. Create a puddle of viridian with a level 2 consistency (see page 32). Using a mop brush or size 12 brush, wet the entire paper. Drop in viridian. Once it begins to spread, drop in more sap green in different areas.

3 Drop in a little more color—this time compose blue and marine blue. Allow colors to mingle on their own and don't overwork them.

4 Drop in some coarse salt where you see that the paper has lost some of its sheen. Drop in a small amount of marine blue in some areas to create deeper tones.

5 Using your heat tool, blow in some areas where you see that water has collected. As the hot air pushes the water, you will see some backruns being formed. Don't get too close or blow in the same areas for too long or you could end up burning it! Let dry.

6 Select a font from your computer. Avoid using fonts that are too skinny or condensed. Type your letter and make it the size you want. Print the letter on regular paper, then, with a lightpad or over a window, trace the letter onto watercolor paper. Use a craft knife to carefully cut out the letter.

7 Now add a gold touch to the letter cutout. Mix a small amount of gold gouache on a palette with small wells. Using a small angled brush, paint the letter outline. When you reach a corner, paint just a little past the turning point. Turn your paper and continue painting in the new direction.

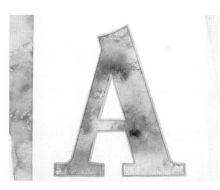

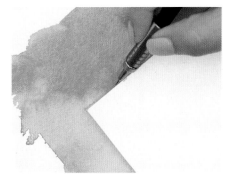

TIP
Practice painting with the gold gouache on scrap paper to make sure your line is the same thickness all around.

8 Create any additional pieces, such as the center of the letter A. Now that your background is dry, gently remove the salt. Place your cutout over your favorite part of the painting. Mark where you will trim the colored background.

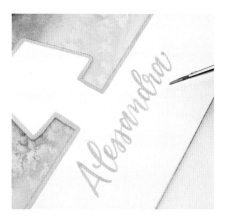

9 Use double-sided tape to adhere any loose pieces. Using the gold gouache, you can letter a name under the initial to further personalize your monogram art.

Customize your letter to your name or your recipient's.

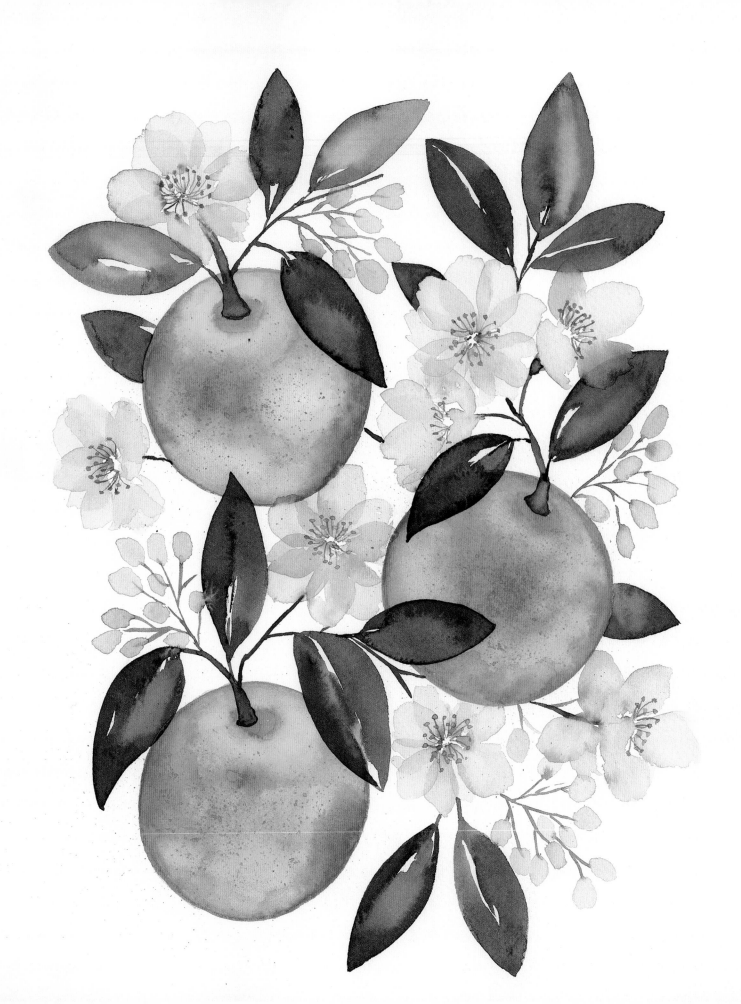

Sweet 'n' Tangy Oranges

Citrus fruits are so much fun to paint. I especially like to paint them during the hot, summer days in Texas. Just the thought of eating a fresh, juicy orange helps me make it through the scalding temperatures. The color orange itself represents warmth and tropical surroundings. It is such a fun and bright color, simply a delight to work with.

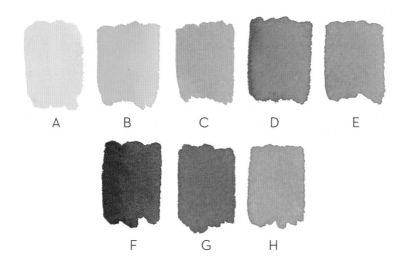

COLOR PALETTE

A. Hansa yellow light • B. Yellow-orange

C. Transparent orange • D. Sap green • E. Olive green

F. Perylene green • G. Burnt sienna • H. Raw sienna

BRUSHES

Size 2 round synthetic

Size 8 round synthetic

Size 10/0 liner brush

TECHNIQUES

Flat wash (page 44)

Charging color (page 50)

Spattering (page 54)

OTHER SUPPLIES

10" x 14" (26 x 36cm) watercolor paper

Old toothbrush

TIP
The next time you paint a fruit, try to find out if it has blossoms you can incorporate. You'll be surprised to see how beautiful they can be.

1 Mix a puddle of Hansa yellow light in a level 1 consistency and one of yellow-orange at level 3 (see page 32). With a size 8 brush and yellow light, paint the outer edge and around the highlights of the first orange.

2 Soften the edges with a clean, damp brush.

3 Pick up some yellow-orange paint and charge color all around the orange as well as the areas around the main highlights, including the stem area. Pick up some sap green paint and drop it on the bottom portion of the orange.

 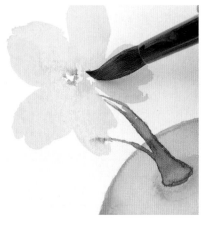

4 Mix a little transparent orange into your yellow-orange mixture and charge color mostly on the right side, some on the left and bottom, as well as the central part of the orange. This gives the orange a three-dimensional look. Allow everything to dry completely.

5 Once your orange has dried, paint the stem using olive green. Charge a little burnt sienna on both sides of the stem to give it depth.

6 Using a size 2 brush and raw sienna, paint a small dotted circle for the center of the flower. Then, using a damp, clean size 8 brush, pull a small amount of paint to create five small petals. This should be a very light color, as orange blossoms are actually white. Let dry.

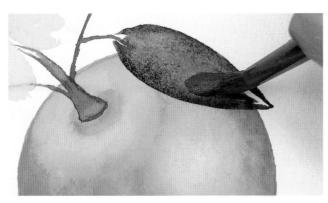

8 Paint a few more leaves and flowers.

7 Using different mixtures of sap green, olive green, and perylene green in a level 2 consistency, paint some leaves. Try to paint gently so you don't disturb the orange color underneath. You want the leaves to be semi-transparent so paint the outer edges first, then, with clean water, fill in the center of the leaf.

9 Once your first layer of petals has dried, paint another five petals, making sure you can still see the first ones. Allow the flower to dry completely.

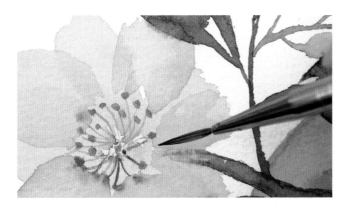

10 Using a liner brush paint the stamen of each flower.

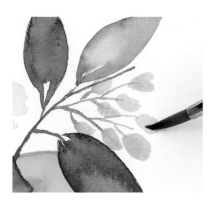

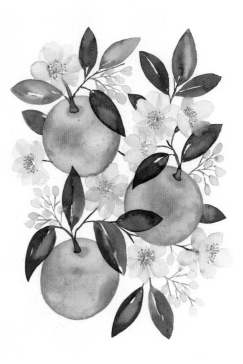

11 Paint small buds with a watery mixture of sap green and raw sienna and the liner brush. Let dry.

12 Using a toothbrush, create some spatters right over the orange for a painterly look.

Templates

Some of the projects include templates to help you get started. Photocopy the template at 125 percent or desired size, place your watercolor paper over the copy, then place both on a lightpad or window (during the daytime!) to trace the image. For any straight lines, you can use a ruler or carefully freehand each line. Use a mechanical pencil with HB lead and go over it with a kneaded eraser to remove any excess graphite. Make pencil lines soft so that they're barely visible. Once you paint over them, they will be impossible to remove.

Origami Bunny (page 75)

Galaxy Rainbow Unicorn (page 78)

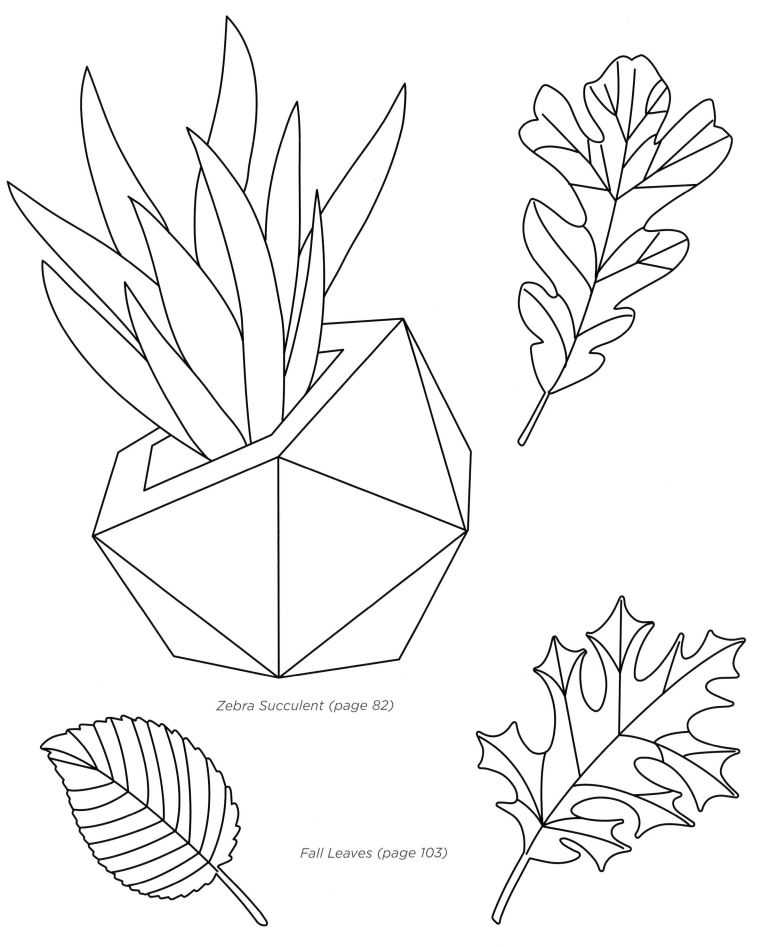

Zebra Succulent (page 82)

Fall Leaves (page 103)

Color Recipes

In this section I want to share with you some of my favorite color combinations. You might not have the exact colors that I use, but that doesn't mean you can't create your own charts with shortcuts to your favorite color mixes!

On the next few pages, I'm going to show you how to make secondary colors out of a few different types of primary colors. The color charts show you how to create different greens, oranges, and violets. I've included a light value and a dark value of each primary and secondary color so that you can appreciate each color at its lightest and darkest value.

These charts can help you mix colors that you might have never thought of mixing before. I was pleasantly surprised several times as I was creating my mixes, and I know you will be, too!

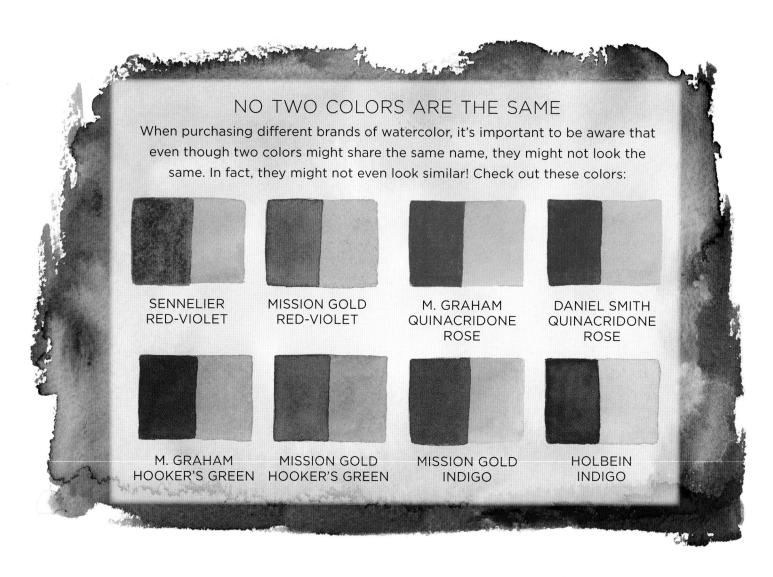

NO TWO COLORS ARE THE SAME

When purchasing different brands of watercolor, it's important to be aware that even though two colors might share the same name, they might not look the same. In fact, they might not even look similar! Check out these colors:

SENNELIER
RED-VIOLET

MISSION GOLD
RED-VIOLET

M. GRAHAM
QUINACRIDONE
ROSE

DANIEL SMITH
QUINACRIDONE
ROSE

M. GRAHAM
HOOKER'S GREEN

MISSION GOLD
HOOKER'S GREEN

MISSION GOLD
INDIGO

HOLBEIN
INDIGO

Greens

We could spend a lifetime mixing different greens and never get bored.

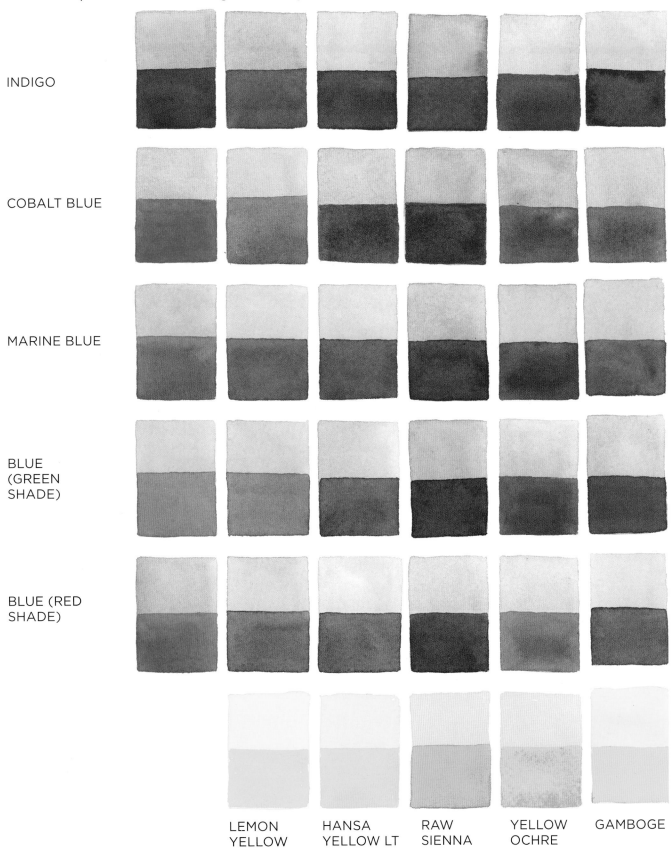

INDIGO

COBALT BLUE

MARINE BLUE

BLUE (GREEN SHADE)

BLUE (RED SHADE)

LEMON YELLOW HANSA YELLOW LT RAW SIENNA YELLOW OCHRE GAMBOGE

Oranges

Some lovely skin tones can be found in the lighter values of custom-made oranges.

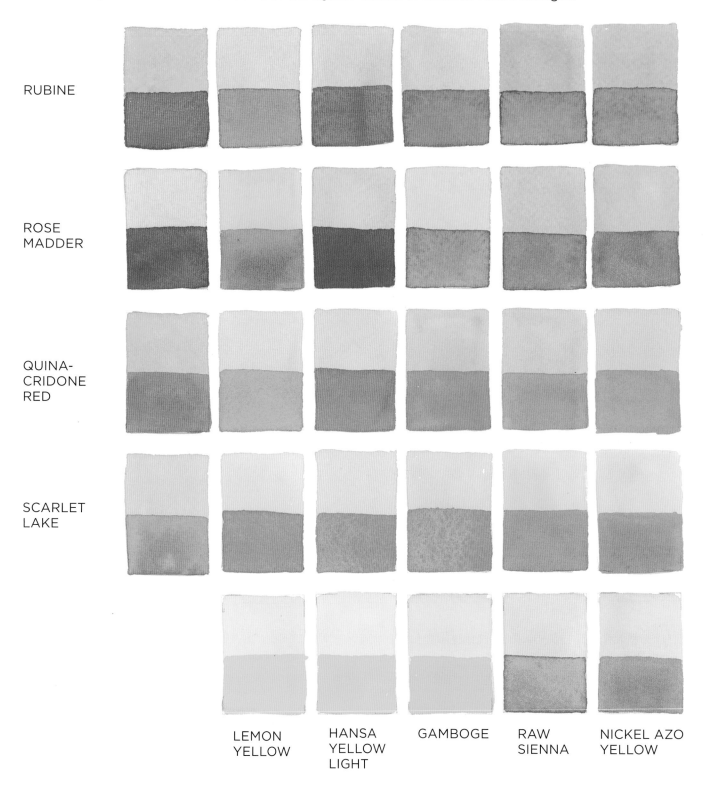

RUBINE

ROSE
MADDER

QUINA-
CRIDONE
RED

SCARLET
LAKE

LEMON
YELLOW

HANSA
YELLOW
LIGHT

GAMBOGE

RAW
SIENNA

NICKEL AZO
YELLOW

Violets

Some of my favorite violets are those I mix myself. They are rich, deep, and vibrant.

INDIGO

MARINE BLUE

BLUE (RED SHADE)

COBALT BLUE

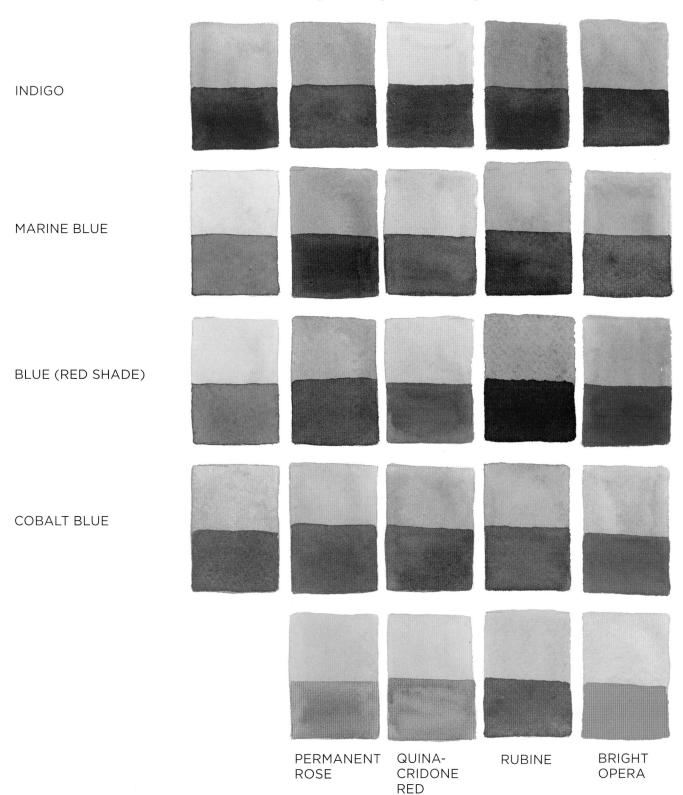

PERMANENT ROSE

QUINA-CRIDONE RED

RUBINE

BRIGHT OPERA

Watercolor All Year Long!

Have you ever sat down, excited to start painting with all the materials ready, and then . . . you just don't know what to paint? Creative blocks happen to artists all the time. So, to help you and me, I'm sharing some prompts and ideas to get us excited about painting with watercolors any time of the year!

January: Geometric Shapes and Patterns

Week 1: Squares

Week 2: Circles

Week 3: Triangles

Week 4: Hexagons

Bonus: Pattern using two different shapes

February: Low Poly Art

These are simple geometric shapes placed side by side to create angular, often minimalist compositions.

Week 1: Geometric heart

Week 2: Geometric animal

Week 3: Geometric fruit

Week 4: Geometric flower

Bonus: Geometric mountainscape

March: Flowers

Week 1: Filler flowers (feature stems with clusters of flowers or multiple blooms: spray roses, wax flowers, solidago)

Week 2: Focal flower (features a single bloom per stem: anemones, peonies, roses, gerbera daisies)

Week 3: Line flowers (tall flowers with multiple blooms per stem: stock, orchids, snapdragons, larkspurs)

Week 4: Entire floral bouquet

Bonus: Wildflowers

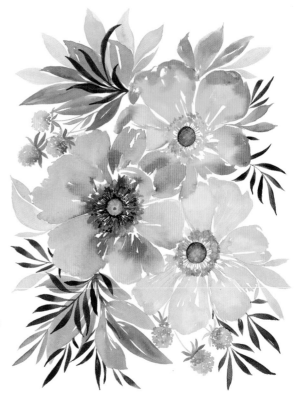

April: Greenery and Herbs

Week 1: Eucalyptus (seeded, silver dollar, willow, baby blue)

Week 2: Myrtle or ivy

Week 3: Rosemary, cilantro, parsley,

Week 4: Mint, sage, basil

Bonus: Greenery wreath

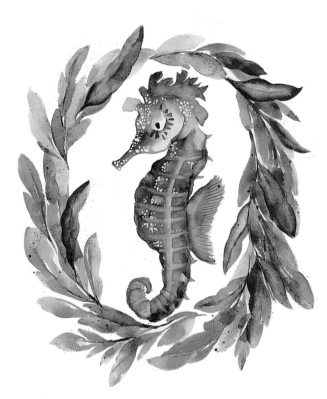

May: Marine Life

Week 1: Coral reef

Week 2: Ocean fishes

Week 3: Marine mammals

Week 4: Seabirds

Bonus: Shellfish

June: Tropical Leaves

Week 1: Philodendron (*Monstera deliciosa*)

Week 2: Areca palm

Week 3: Fancy-leaf caladium

Week 4: Royal fern

Bonus: Tropical citrus leaf

*Share your work with us on Instagram
using this hashtag: #hellowatercolorchallenge*

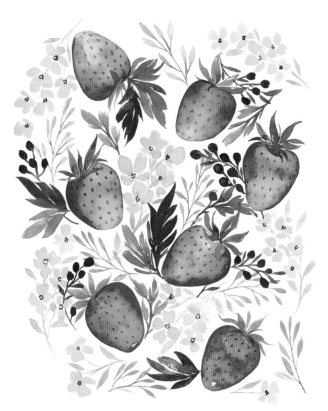

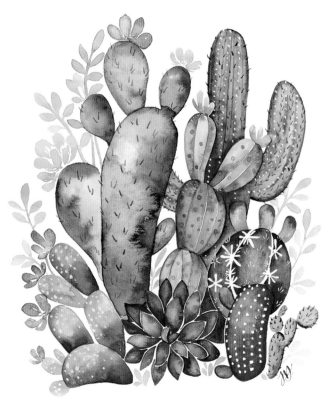

July: Fruits

Week 1: Tropical fruits (mangoes, papayas, pomegranates, kiwifruits)

Week 2: Citrus fruits (blood oranges, key limes, mandarin oranges, lemons)

Week 3: Stone fruits (cherries, peaches, plums, mangos)

Week 4: Fruits in disguise (avocados, tomatoes, cucumbers, eggplants)

Bonus: Your favorite summer fruit (mine are strawberries!)

August: Cacti & Succulents

Week 1: Saguaro cactus

Week 2: Prickly pear

Week 3: *Zebra haworthia* succulent

Week 4: Jellybean succulent

Bonus: Flowering cactus

September: Ink Doodles and Watercolor

Drawing doodles using waterproof pens and then adding watercolors.

Week 1: Bugs and butterflies

Week 2: Botanicals

Week 3: Gemstones

Week 4: Letters

Bonus: Birds

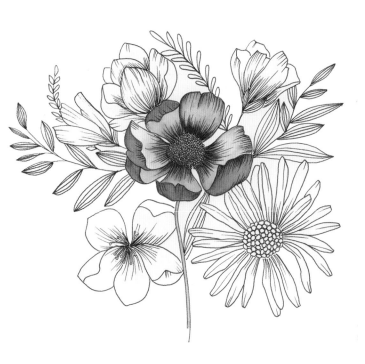

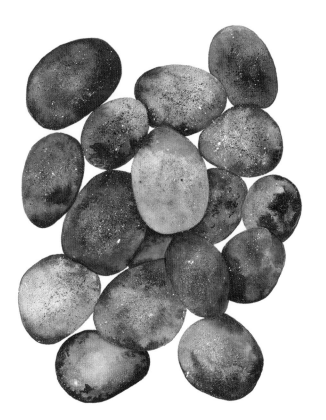

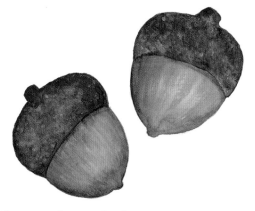

November: Autumn

Elements by color: leaves, pumpkins, gourds, acorns, trees, mushrooms, etc.

Week 1: Yellow

Week 2: Orange

Week 3: Red

Week 4: Green/brown

Bonus: Purple

October: Out of This World

Week 1: Galaxy rocks

Week 2: Galaxy animal silhouette

Week 3: Galaxy letters (initials or a whole word!)

Week 4: Galaxy feathers

Bonus: Galaxy numbers

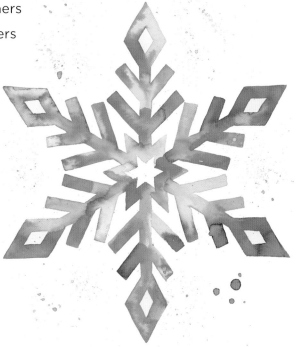

December: Winter Elements

Week 1: Evergreen trees

Week 2: Poinsettia flowers (pink, white, red) and winter berries

Week 3: Snowflakes

Week 4: Christmas floral wreath

Bonus: Christmas ornaments

Share and Connect

When I first started painting and lettering, it was important to me to document my progress. Along the way, I began sharing my journey online. I never imagined all the doors that would be opened and the people I would meet through sharing my work. Creating is something so personal and meaningful to us that we may be tempted to keep it all to ourselves, but by sharing our work with others, we continue to bloom and grow.

In sharing my work with other like-minded individuals, I learned the following:

- To push boundaries and try new things.
- To work toward excellence, not perfection.
- To enjoy and not overlook the creative process. After all, it's the vehicle that got me where I am today and will continue to take me through my creative journey.
- To be inspired by the work of others! Creativity *is* contagious!
- To deal with negative comments. The way I do this is by evaluating if a comment adds or takes away. If it's a constructive criticism, I'll keep it in mind. If it's the destructive kind, I'll put it out of my mind. My work will always have worth in my eyes.
- To appreciate my work and know that it is always changing and evolving as I find new ways to express myself.
- That there are others out there who can relate to me and my work!

Here are a few things to consider when sharing your work:

Photos and Videos

To take the best photos possible, try these tips.

Pay attention to lighting. Natural light is great, but if it's not available use a good neutral artificial light source. Not too warm, not too cool. Video and photography lighting solutions such as ring lights, softboxes, and lighting umbrellas are excellent tools and worth the investment. Avoid using excessive lighting. When you use too many lights, your paintings can become washed out.

Take several shots. Out of all the dozens of photographs you take, only one or two may end up working.

Use different angles. Every photograph doesn't have to be taken head on.

Leave your tools in the shot. Photographs that are always styled similarly can become monotonous. Your props can be the tools you used. People are interested in knowing the backstory of your painting, your setup, etc.

Show the process. You can use your smart phone mounted on a tripod to film the entire thing. Then use an app to create a time-lapse video of your work.

Keep your hand in the picture? Well yes, you can! I often do this to help protect my original artwork. But make sure your nails are clean. Dirty nails are a real turnoff.

Use a photo-editing app. It's useful for adjusting the color on your photos and videos and removing unwanted sound.

Don't use crazy photo filters. Especially some of the ones available on Instagram. Try to keep your photos bright and clean with colors as close to the original as possible. No

need to add vintage filters or dark vignettes or oversaturate colors.

Add a watermark. Choose a tasteful logo with your name or company that you can add to each picture or video and put it where it would be hard to get cropped out. Unfortunately, there are people who will repost your work without your permission and might not credit you.

Tagging and Hashtags

Tag the brand of any materials you use. Many companies are now active in social media, so tagging them is a good idea! Use hashtags that are relevant to your art. They don't always have to be the same; you can change them up a bit. If you were inspired by someone and created artwork that looks similar to theirs, you should tag them. And never repost artwork that others have created without proper credit.

Here are some popular hashtags for **watercolors:**

#watercolor
#aquarelle
#watercolorpainting
#makersgonnamake
#watercolour
#paintingoftheday
#art
#instacool
#instaartist
#instadaily
#watercolorillustration
#artsogram
#dailyart
#painting
#sketch
#artwork
#illustration

Connecting with Others

When you enter this community, you will find that there is a great deal of support and encouragement from fellow artists just like you. Make sure to comment and encourage others on their creative endeavors as well. If you see something you like, let the artist know. It'll help build relationships and make connections. And join others in creative art challenges, such as the one we share in this book (see page 139)!

Index